IMAGES
of America

WEST BLOOMFIELD
AND THE TRI-CITIES

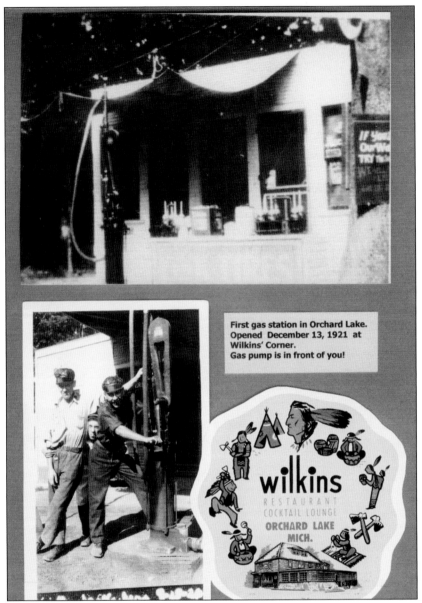

First gas station in Orchard Lake. Opened December 13, 1921 at Wilkins' Corner. Gas pump is in front of you!

wilkins
RESTAURANT
COCKTAIL LOUNGE
ORCHARD LAKE
MICH.

Fred and Bertha Wilkins opened a small store and filling station at Orchard Lake Road and Pontiac Trail in 1921. With the advent of inexpensive automobiles, the lakes area became overrun with weekend and summer visitors. The Wilkins's business thrived, becoming Wilkins Restaurant. Sadly, in 2014, the building was razed. We pay tribute to the Wilkins family and the many decades of great dining and hospitality. (Courtesy of Greater West Bloomfield Historical Society.)

ON THE COVER: Jerry (left), Al (center), and Sam Gray represent three generations of membership in the Pontiac Yacht Club. They are seen here in 1952. The club is located in the City of Orchard Lake Village, with frontage on Cass Lake. The club was formed by members of the Oakland County Boat Club in Sylvan Lake, who left to create a more family-oriented club. Coincidentally, the club is for sailing only. (Courtesy of Joan Green.)

IMAGES
of America

WEST BLOOMFIELD
AND THE TRI-CITIES

Ronald K. Gay

ARCADIA
PUBLISHING

Published by Arcadia Publishing
Charleston, South Carolina

Printed in the United States of America

Library of Congress Control Number: 2014942395

For all general information, please contact Arcadia Publishing:
Telephone 843-853-2070
Fax 843-853-0044
E-mail sales@arcadiapublishing.com
For customer service and orders:
Toll-Free 1-888-313-2665

Visit us on the Internet at www.arcadiapublishing.com

 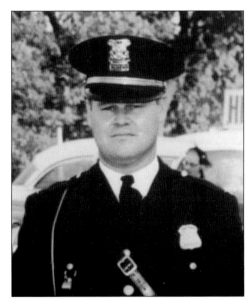

Sergeant Patrick John O'Rourke (left), West Bloomfield Police Department; End of Watch, September 9, 2012. (Courtesy of the West Bloomfield Police Department.)

Police Chief, Firefighter, Calvin Baxter (right), Keego Harbor Police Department, West Bloomfield Fire Department; Last Alarm, October 4, 1956. (Courtesy of Greater West Bloomfield Historical Society.)

CONTENTS

ACKNOWLEDGMENTS

Thank you Glenn Gilbert for writing the chapter introductions on this history of our communities and for your other helpful suggestions and oversight. Many thanks to all who have donated photographs and time to represent all the communities in this book, including Helen Jane Peters; Coral Lou Walling; Joan Walsh; Molly Rozycki; Kyle Staulter; Joan Green; Mark Periard; Jan Morrill; Don Larson; Hugh Dickie; Pat Dickie Pittenturf; Bob Green; Marcin Chumiecki, J.J. Przewozniak, and Orchard Lake Schools; Jim Farhat and Pine Lake Country Club; Tim Ward and Orchard Lake Country Club; Feiga Weiss and the Holocaust Memorial Center; Robbie Terman and the Leonard N. Simons Jewish Community Archives; Paul Anger, Jody Williams, and the *Detroit Free Press*; Ruth Fruehauf and Fruehauf Trailer Historical Society at www.singingwheels. com; David Sgriccia and the Detroit Curling Club; the Reverend Paul Thwaite, Gordon Steele, and the Orchard Lake Community Church, Presbyterian; Officer Rick Trabulsy and the West Bloomfield Township Police Department; Library of Congress; Oakland County; Countryside Improvement Association; American Academy for Parks and Recreation Administration; Detroit Public Library/Burton Historical Collection; Bentley Historical Archives; Hank Callahan; Paul Benson; Chris Angott; John and Patty Hartwig; Mark Thomas; Daisy Worley; Neil Woodward; Joan Abbey; Earl Partica; Geoff Brieger; Kathy Jenkins; Cheri Gay; Leslie Edwards; Bruce McIntyre; and Bill Bertakis. Thanks to local authors for writing so thoroughly about our local history in *Reflections on the History of West Bloomfield* by Charlie Martinez (2004, Greater West Bloomfield Historical Society) and *Them Was the Days!* by Brian J. Bohnett (2001, Mad Kings Publishing).

Special thanks to the Greater West Bloomfield Historical Society (GWBHS), including Christy Forhan, Gina Gregory, Sue Williams, and Buzz Brown.

INTRODUCTION

West Bloomfield Township, Michigan, is one of the earliest inland settlements in southeast Michigan, although it did not become a township until 1833. It was originally occupied by Native Americans of various tribes, as was the case with other settlements in the region.

The European American settlers migrated to the region steadily after the War of 1812, predominantly from the Northeast. They found the area perfect for farming, establishing orchards, and grazing animals, particularly sheep. The population grew after the opening of the Erie Canal in 1825. Farms dominated the township landscape well into the 20th century, even though campers, vacationers, and lakeside cottage dwellers began to populate the area around the lakes as early as 1900.

The native people were still here well into the 20th century. Despite rumors of Indian reservations existing within the township in its early days, there are no records indicating that this is the case, at least in terms of federally designated reservations. Apple Island, more or less at the heart of the township, in the middle of Orchard Lake, is renowned for its Indian inhabitants, with their tales of ghosts and lost loves. The island is named for the apple trees planted by the Indians that ultimately provided seeds for more orchards on farms of the newly arriving Anglo settlers. The tale that many baby-boom schoolchildren heard, of Chief Pontiac being buried on Apple Island, has all but been dismissed as local legend with no basis in fact.

Pontiac, an Ottawa chief, is best remembered for his efforts to try to take back Fort Detroit from the British occupiers. A nearby city bears the name of the chief, as well as a prominent road in the township, Pontiac Trail.

As a farming community, the early township consisted mostly of large tracts of land owned by single families and often successive generations. Some of the earliest European American settlers were Scotch. They brought with them the sport of curling, which fit perfectly with the many lakes and cold winters. Scotch School is named for these early West Bloomfield settlers.

The Tri-Cities were carved from the township. The area that became Orchard Lake Village was an early destination for weekend campers. Keego Harbor began platting its first subdivision as early as 1910, but it was the Village of Sylvan Lake that was first formally established as a legal entity, a village, and then a city. Resort hotels had existed in three township locations already when the Sylvan Lake Inn was built in 1895. The small lake community began by platting the land around the hotel between Orchard Lake Road and Sylvan Lake. Most of the early residents were cottage dwellers.

Next came Keego Harbor, which was established on a similar premise as Sylvan but without a resort. It actually was not an official entity until 1955, when it became a city. It was the one community that offered a downtown of sorts early on. The harbor is actually a tiny lake that became a harbor thanks to founder Joseph E. Sawyer, who connected it to the large Cass Lake by way of a man-made canal.

Early on, Orchard Lake had two resort hotels, a military academy, and throngs of weekend campers and cottage dwellers, but it was not formally organized into a village until 1926. The corner of Orchard Lake Road and Pontiac Trail was a point of convergence from Detroit and surrounding areas, as well as a divergence into the lakes regions early on for vacationers and summer residents. Orchard Lake Road was not just a major roadway to various parts of the township and county, it was also a direct route into Pontiac, where the population of year-round residents was highest in the early years. Many of the summer residents came from and through Pontiac. The railroad, the

Detroit United Railway interurban line, and decent main roads emanating from the larger cities all helped to bring people to the area, especially during the summer months as a refuge from the heat of the city of Detroit. They also came from other regions and states. Lack of air-conditioning and city parks and the prevalence of noise, dirt, and commotion in the city were motivators for Michiganders to head to the lakes come summer and weekends.

Through the years, there have been many significant and eventful episodes in local history. Chief Pontiac and the various local tribes over the centuries anchor the community's roots in Native American significance. The earliest apple orchards gave way to a tradition of orchards and a reputation for the same in southeast Michigan. West Bloomfield was a wool-producing Goliath for decades.

The Automobile Club of Detroit built its first clubhouse on the north shore of Pine Lake. It evolved into Pine Lake Country Club, the township's first such establishment. More clubs followed, including an aviation country club for a short stint. A boat club, a sailing yacht club, a camp for female immigrant factory workers, a camp for lower-income city kids, ferry boats, electric railways, canoe rentals, and swimming beaches were all abundant at some time or another in West Bloomfield history.

Through the years, cottages evolved into year-round homes. Farms became subdivisions and strip malls. There have been many distinguished inventors and industrialists, a women's club that became the first library, and notorious gangsters during Prohibition who came to the area for summer kicks. Little League teams sprang up with the baby-boom kids spilling out of neighborhoods. School districts changed and grew. New schools sprang up frequently until school-age children declined in numbers in the 1980s and 1990s.

Zox Lakeside Park, also known as Little Venice, is a development on Cass Lake designed to give each homeowner frontage on the water. The multitude of canals and bridges carved out of otherwise dry land led this resort community, like so many other neighborhoods of its day, to morph into year-round residences.

Westacres, the vision of James Couzens, is another unique community, but instead of being created for seasonal residency, it was a direct outgrowth of the nearby automotive industry in Pontiac and other areas around Detroit providing year-round homes. It was more communal in nature with a co-op, a result of the Depression years. West Bloomfield Township profited greatly from the automotive boom years. It is what it is today because of the incomes and families generated as a result of that industry.

A one-room schoolhouse is extant with the old Pine Lake School. Pine Lake Cemetery dates to the earliest years of established settlements here. Among the many businesses, places, and institutions associated with West Bloomfield Township are Flanders Automobile Company, Fruehauf Trailers, Flint Ink, Detroit Curling Club, Keego Cass Women's Club, Rotunda Inn, Charley's Crab, Wilkins Restaurant, Orchard Lake Community Church, Trinity Methodist Church, Pontiac Yacht Club, Oakland County Boat Club, Lakeland Athletic Association, Interlaken Hotel, Orchard Lake Hotel, Sylvan Lake Inn, Old Farm Subdivision, Sylvan Manor, Hammond Lake Estates, Pine Lake Estates, Bloomfield on the Lake, Deerfield Village, Powderhorn Estates, Keego Hardware, Keego Theater, Dickie Lumber Company, Howell's Lumber Company, Michigan Military Academy, Polish Seminary, Jewish Community Center, and the Holocaust Memorial Center—not to mention Bob Seger and the Silver Bullet Band.

While the township is an example, like many other communities across Michigan, of being virtually all white subsequent to the dispersal of the native peoples, it has become an extremely diverse community and can be appreciated for its ethnic restaurants, houses of worship, and markets. It was an integral part of the Underground Railroad, with at least one house being said to be on the route. At least one African American family lived here early on, in the mid-19th century, which was unusual for outlying areas of that period.

Whether it is ice-fishing, skating, or sailing in winter or swimming, waterskiing, sailing, and picnicking in summer, the area is fortunate to have 25 lakes, the lushness of many varieties of vegetation, and a great selection of shops, restaurants, businesses, and institutions.

One

WEST BLOOMFIELD EARLY

Maj. Oliver Williams and a few other venturesome pioneers simply did not believe what they had been told. Surveyors after the War of 1812 checked out the terrain of an area in what is now southeastern Michigan and said it was too swampy and unsuited for agriculture. But, with the blessing of territorial governor Lewis Cass, in the fall of 1818 Williams and his companions set out to see for themselves.

They found that the land turned into good soil if one ventured far enough from Detroit. Going west, they arrived at Orchard Lake, traveled around the northern shore, and crossed the isthmus separating Orchard and Cass Lakes. The honor of being the first legal landholder in West Bloomfield went to Benjamin Irish, who acquired property on the west side of Walnut Lake in 1823; however, the first recognized settler is John Huff, who erected a log cabin on the southeast shore of Pine Lake in 1821. That year also saw the first township road cut through and used. It came down from the northeastern corner by Hammond and Long Lakes and then went south around the corner of Pine Lake, serving as the basis for the route of present-day Middle Belt Road. In 1828, a school was established in a log cabin between Walnut and Pine Lakes.

Pine Lake Cemetery, dating back to 1831, is located north of Lone Pine Road on Middle Belt Road. Charles Lindbergh's mother is one of the people buried in the small cemetery, as is baseball great Norman Cash. Hosner Cemetery, located on Farmington Road between Fourteen and Fifteen Mile Roads, dates back to 1836 and has a historical designation.

The first post office was established in 1832 at the home of John Ellenwood, the second township supervisor. The area officially became West Bloomfield Township in 1833, when Governor Cass broke it off from Bloomfield Township. Before the Civil War, a local home hid runaway slaves who were traveling between Pontiac and Farmington stops in the Underground Railroad. The house still stands.

The township was made more accessible in 1895 with the construction of a new rail line, a spur of the Grand Trunk Air-line Division, which stopped at a depot in Orchard Lake. Also, by 1893, Orchard Lake Road was famous for its gravel surface, which permitted faster and smoother transit.

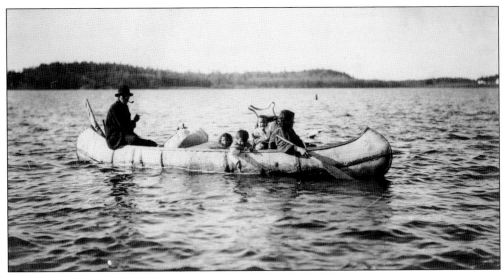

The Atlas of Great Lakes Indian History, by Helen Tanner, describes Ojibwa and Potawatomi tribes around the lakes of the future West Bloomfield Township in 1830. It is known that Chief Pontiac, who lived in the area in the 1700s, was from the Ottawa tribe. The birch bark canoe shown here was common in the area with various tribes. The native population in the Michigan Territory around 1830 was about 14,000. (Courtesy of the Library of Congress.)

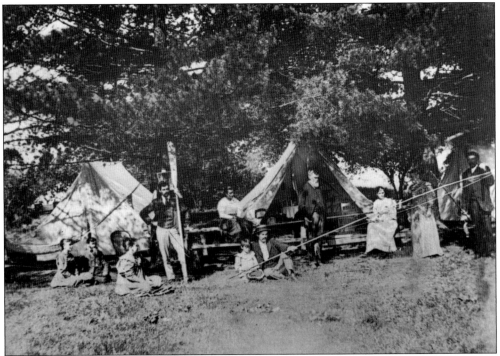

Marshbank Park is on Cass Lake's west shore. This scene reflects early camping on the lake, when people trekked out from Pontiac and pitched tents in the summer to take advantage of the cool, refreshing waters close by and the peacefulness of the undeveloped wilderness. This area gave city dwellers a break from urban life, even in the days before automobiles. (Courtesy of Joan Walsh.)

Theron Murray purchased 80 acres from the US government in 1831. He and his wife, Rebecca, raised two sons on their West Bloomfield farm, which became prolific in growing apples, as did their sons' farms. The Murrays were growing fruit before the Civil War, but it was the advent of canning that increased demand after the war. By 1880, ninety-seven percent of farms in the township were producing fruit. (Courtesy of Earl Partica.)

Theron Murray was highly respected in his community, not only for being a successful farmer, fruit grower, and businessman, but for being honest and forthright. He never sued another man, nor was he ever sued. Murray, a Universalist in matters of faith and a Republican in politics, did not believe in speculation but in steady, calculated, hard work. (Courtesy of Earl Partica.)

Rebecca E. Welfare of Commerce, Michigan, became Rebecca Murray in 1832 when she and Theron Murray were married. Together, they built one of the most productive fruit farms in the township. She bore two sons, Ozro and Albert, who built homesteads of their own to either side of their parents' property. The sons gave Theron and Rebecca five grandchildren. (Courtesy of Earl Partica.)

Daniel Whitfield, born in England in 1823, married Sarah Jane Bradford in 1851. They were residents of Bloomfield Township, near what is now Sylvan Lake. He was an assessor at one time in his life. He donated land for the building of what would be Daniel Whitfield Elementary School. Early versions of the school have been referred to as Hammond and Skae Schools. (Courtesy of Helen Jane Peters.)

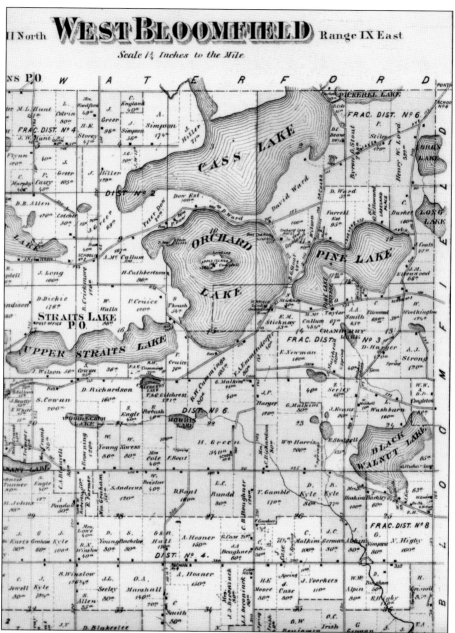

This 1896 map of West Bloomfield includes details of many of the property owners and schools, as well as the names of roads and lakes. The township was divided into fractional school districts. Whitfield, for instance, in what became Sylvan Lake, was in Fractional District 6. Pine Lake School, at the southwest corner of Middle Belt and Long Lake Roads, was in Fractional District 3. The schools are only known by number on this map. Walnut Lake is Black Walnut Lake, Otter Lake is called Pickerel Lake, and Hammond is Lords Lake. The Dows, Wards, and Campbells owned most of the land between Orchard and Cass Lakes, including Apple Island. General Copeland is shown as the owner of the land that became the Michigan Military Academy, though it is the Orchard Lake Hotel here. The hotel at what is now the historical museum was the Orchard Lake House and H. Weston Landing. (Courtesy of GWBHS.)

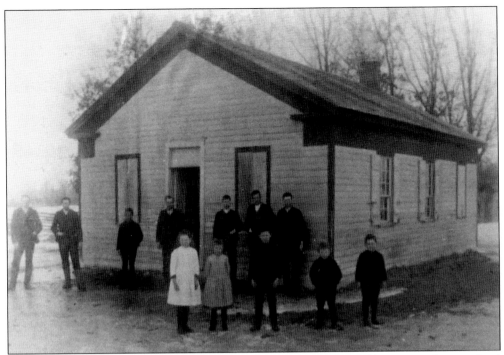

In 1852, the first Whitfield School was established on a site that would see many future school buildings. It was designated Fractional School District 6 in the township. The first teacher was Samuel Rod. He was required to teach 24 days per month, which meant a Saturday or two. For teaching four months of the year, he was paid $18. (Courtesy of Helen Jane Peters.)

The George Hammond Company was known for revolutionizing refrigerated railroad cars, primarily for the transportation of beef across the country. While he is not credited with the first patent for this type of refrigeration, Hammond made this technology available on a large scale. Hammond Lake is named for the family, as was Detroit's first skyscraper, the Hammond Building, which was erected with structural steel. (Author's collection.)

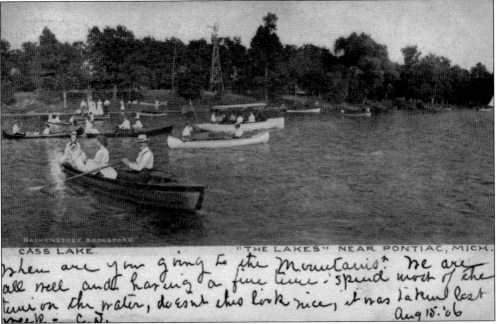

The handwritten caption of this postcard, sent from a summer resort on Cass Lake, reads, "When are you going to the mountains? We are all well and having a fine time. Spend most of the time on the water, doesn't this look nice, it was taken last week—C.J. Aug 15, '06." The postcard photograph was taken by Backenstose Bookstore in Pontiac. (Courtesy of Joan Walsh.)

Orchard Lake Road is seen here as it passes by Pine Lake. It was still a dirt road in the early part of the 20th century, and the increase of automobile traffic presented a new problem for property owners. City dwellers invaded the lakes on weekends during the warm months, disturbing property by creating dust, noise, and havoc. (Courtesy of Joan Walsh.)

The house on the left was built by Orville C. Morris in 1897. It still stands where Pine Lake Road jogs off of Orchard Lake Road. It is an eclectic mix of Gothic Revival and Queen Anne style. The Y-shaped intersection is no longer there, and a large house now stands before the grand Victorian. The carriage house still stands at the rear of the property. This is a turn-of-the-century postcard. (Courtesy of Joan Walsh.)

As evidenced by the size of these cottages, even before year-round homes were built around these lakes people of means were buying up land for their summer homes on the south side of Pine Lake at the turn of the century. (Courtesy of Joan Walsh.)

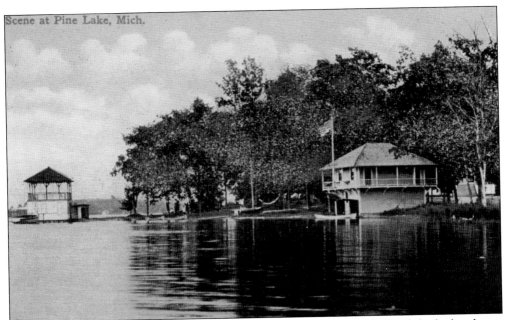

The turn-of-the-century boathouse at left belonged to the Interlaken Hotel, while the boathouse at right was privately owned. Early boathouses were built beyond the water's edge, or areas were dredged, allowing the lake to fill them, thus creating a garage where boats were protected from weather, vandals, and rough seas. The construction of new boathouses is no longer permitted, but previously existing ones can continue to be used and improved upon. (Courtesy of Joan Walsh.)

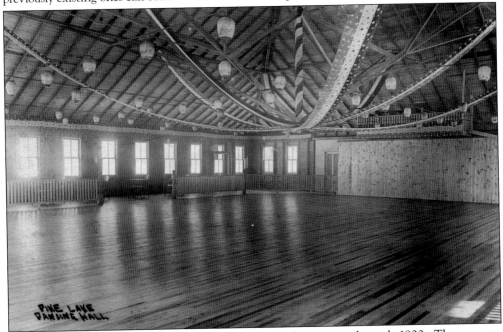

At the Interlaken Hotel and elsewhere, dancing was big business in the early 1900s. There was no better entertainment on a warm night, especially in summer resorts like this one. Many resorts had open-air dance floors and survived for decades before falling out of favor, replaced by other forms of entertainment such as roller-skating and drive-in movies. (Courtesy of Joan Walsh.)

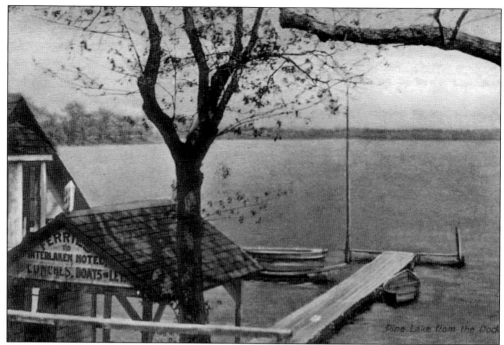

The train station is across the street from this landing. Visitors could choose from two means of travel to the Interlaken Hotel upon arriving at the station. One was by using a ferryboat. This postcard shows the steam-powered ferryboat dock. A horse and carriage could also take a traveler by way of Orchard Lake Road to Long Lake Road. But, the ferry was the most direct and, undoubtedly, the fastest route. (Courtesy of Joan Walsh.)

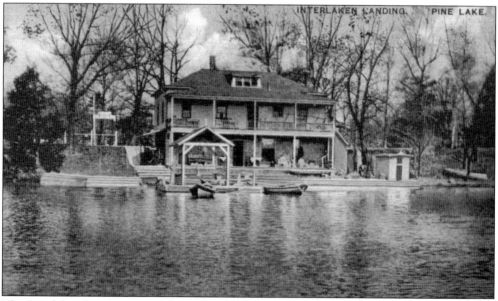

The Interlaken Landing is seen here from the lake. It began as a launching point for tourists traveling to the Interlaken Hotel. Today, it is a marina that rents out boat slips and has a ski school. Pine Lake comprises 395 acres, is spring fed, and is one of the cleanest lakes in the region. (Courtesy of Joan Walsh.)

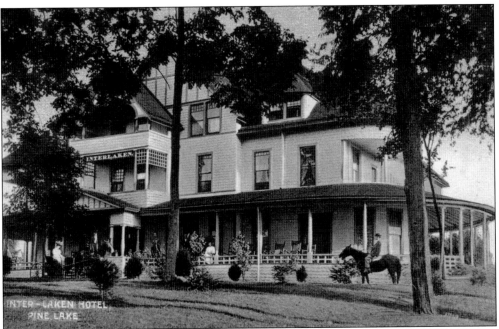

The Interlaken Hotel opened in May 1889, joining two other nearby resort hotels. The resort was part of a larger community with individual homesites, three parks, and easements to the lake for all residents. Much credit can be given to this privately owned community for encouraging others to move to Pine Lake and the area. This image dates to 1910. (Courtesy of Joan Walsh.)

The Automobile Club of Detroit.

Detroit, Mich., March 17, 1905.

Dear Sir :--

We beg to enquire,

(1) Are you in favor of retaining the present "Club House," which is located out Woodward Ave., just this side of Birmingham?

(2) If not, would you be in favor of securing suitable Club quarters at Orchard Lake?

(3) If you are not in favor of either, what would you suggest?

Our lease on the present "Club House" property expires the 31st inst., and before taking action on its renewal, we desire an expression from all members. Let us have your reply on the attached card at once.

Yours very truly,

THE BOARD OF DIRECTORS.

The Automobile Club of Detroit was founded by automotive and industrial pioneers in 1902 at the Detroit Club. Its first board of directors included Russell Alger Jr., Frederick Alger, Philip McMillan, Henry Joy, W.H. Burtenshaw, Dexter Mason Ferry Jr., Gilbert Lee, Charles Ducharme, and Truman Newberry. When this notice was issued, the club had already moved out of Detroit and located on Woodward Avenue, south of Birmingham. (Courtesy of Pine Lake Country Club.)

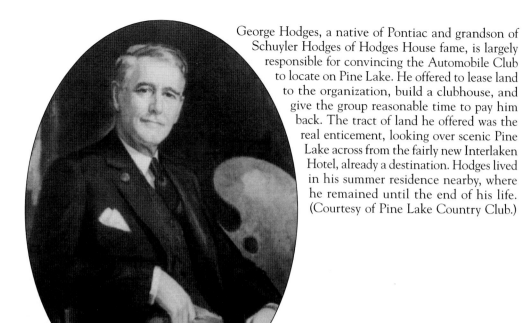

George Hodges, a native of Pontiac and grandson of Schuyler Hodges of Hodges House fame, is largely responsible for convincing the Automobile Club to locate on Pine Lake. He offered to lease land to the organization, build a clubhouse, and give the group reasonable time to pay him back. The tract of land he offered was the real enticement, looking over scenic Pine Lake across from the fairly new Interlaken Hotel, already a destination. Hodges lived in his summer residence nearby, where he remained until the end of his life. (Courtesy of Pine Lake Country Club.)

Pine Lake School became the first official school in the township in 1828, though it was housed in a log structure before moving into this building on the southwest corner of Middle Belt and Long Lake Roads. The structure was built in 1886 at a cost of $850. It was a one-room schoolhouse that received electricity in 1916. Its concrete-block foundation is not original to the building, which still stands on the corner, now as a residence. (Courtesy of Oakland County.)

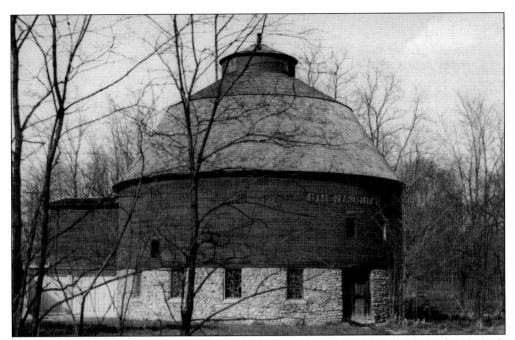

This round barn, christened Shenandoah, was built by the John Miller family in the 1890s. It represents a style of barn architecture considered more efficient to operate and cheaper to build. The style also includes octagonal barns. This one was converted to a residence many years ago, and it still has the old concrete paved driveway leading to its doors. (Courtesy of Molly Rozycki.)

This page of the visitor's register at the Automobile Club of Detroit is from 1906, only a year after the organization's clubhouse was established at Pine Lake. The curious doodles were drawn by James Scripps Booth, who had an automobile company, Scripps Booth, from 1913 to 1923. The brand was owned by General Motors starting in 1916. Note the large number of women's names in the register, including Grace Ellen Booth. (Courtesy of Pine Lake Country Club.)

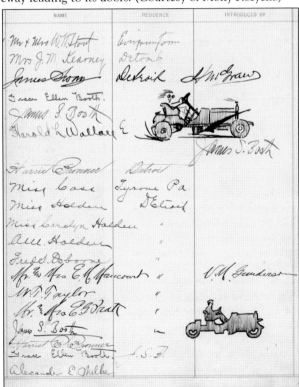

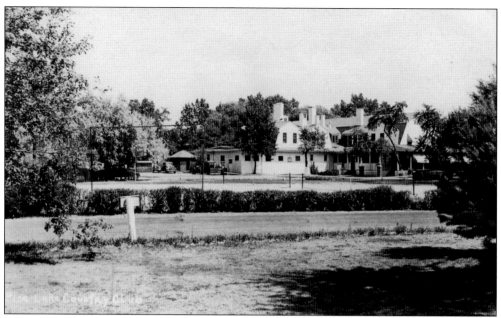

The establishment of good roads, the promotion of the use of the automobile, and influencing legislation to regulate roads and driving were the early goals of the Automobile Club of Detroit. This photograph shows the club from Pine Lake Road, most likely before World War I. By 1916, the club was known as the Automobile Country Club, as it aimed to diversify its mission and purpose. (Courtesy of Joan Walsh.)

Leona McDonald was 11 when she began working at the country club on Pine Lake. One day, she was told to sweep the porch on the lakeside. She found an older man out there tinkering with a bicycle. She went back inside and complained to the head housekeeper that a workman was on the porch and in her way. "That's no workman," the housekeeper replied, "that's Henry Ford." (Courtesy of Joan Walsh.)

The Countryside Improvement Association was formed by a group of women in 1911 to deal with the negative effects of the increased automobile traffic around Orchard, Pine, and Cass Lakes. One of its many goals was to keep dust down on the roads, as most thoroughfares were unpaved at the time. This receipt is for a product used to spray the roads for that problem. (Courtesy of Countryside Improvement Association.)

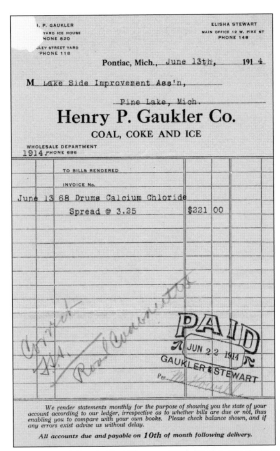

In 1916, the Countryside Improvement Association held a fundraiser on the northwest shore of Hammond Lake. It raised $5,000 toward the cause of keeping dust down, improving road signage, and exploring ways to protect private property from weekend picnickers. These girls dance at the fundraiser, choreographed by Georgia Hoyt of Pontiac. The event coincided with the centennial of Oakland County. (Courtesy of Countryside Improvement Association.)

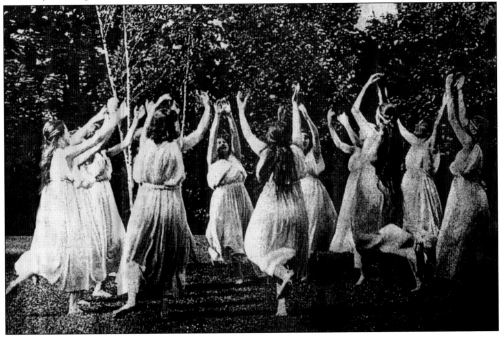

The Girl's Friendly Society was organized in England to provide support for young ladies working in urban factories away from their families. The organization created summer camps, called Holiday House, such as this one on the east shore of Pine Lake. The first such camp located in the township was established on the north shore of Pine Lake in 1895. (Courtesy of Joan Walsh.)

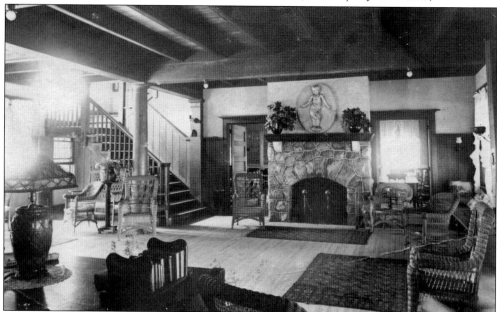

This is the interior of the Holiday House main cottage, which had opened in 1902 on the old Ellenwood property just off of Middle Belt Road north of Long Lake Road. Of the three housing units, one was the old Ellenwood farmhouse, renovated for use by the camp. Henry and Clara Ford were among the many prominent supporters and contributors to the camp, even donating a new Ford for the camp vehicle. (Courtesy of Joan Walsh.)

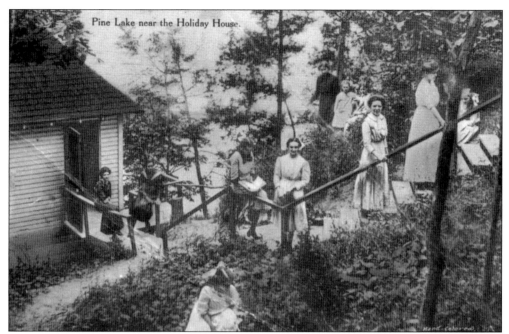

Like other lakefront resorts and communities, there were two choices of transportation to the camp upon arriving at the train depot off of Orchard Lake Road. A carriage could take campers by way of Pine Lake Road to the Middle Belt Road entrance, or *Lady of the Lake,* a steam launch, could take the campers from the Interlaken Landing to the steps at the lakeshore at Holiday House. (Courtesy of Joan Walsh.)

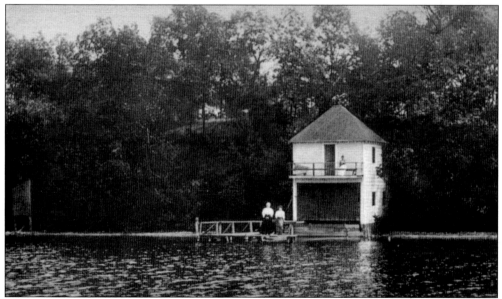

Activities such as swimming, boating, sewing, and singing were set in a bucolic area, away from the toils of mill life and hard labor. As years passed, the camp for the Girl's Friendly Society catered to girls from the surrounding area wanting a camp setting and a summer escape. Seen here is the boathouse and bathhouse. Rowboats and canoes were housed below, and changing rooms and recreation space were located upstairs. (Courtesy of Joan Walsh.)

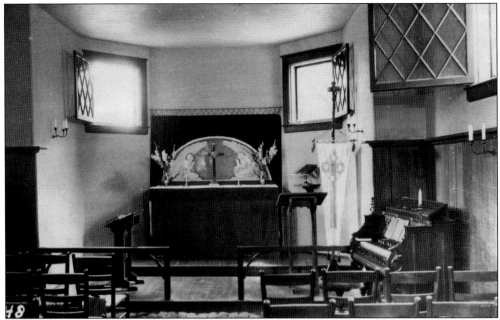

The Holiday House chapel offered a place for voluntary prayer and evening hymns. Across Middle Belt Road from the camp proper were 83 acres of agricultural land used for raising food for the camp. (Courtesy of Joan Walsh.)

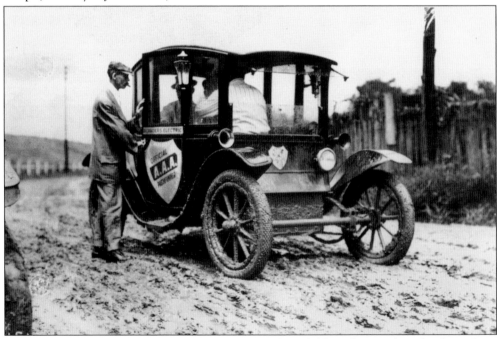

The Flanders Electric vehicle was named for West Bloomfield resident Walter Flanders. These cars, built in Pontiac, Michigan, were manufactured between 1911 and 1914 and were also called Tiffanys. Flanders Manufacturing Company was a consolidation of no less than five companies, including Pontiac Motorcycle Company, when it was capitalized at $2.5 million. (Courtesy of Mark Thomas.)

Walter Flanders was one of the most significant players in the early automobile industry. It is no secret that he was instrumental in developing the assembly line with Henry Ford. Documents show that when he left Ford, he took production-line assembly methods to new levels of efficiency and profits. Flanders was a founder of EMF Company, among several other automotive startups. His Flanders Manufacturing, of Pontiac, failed at making motorcycles and electric cars, of which only 100 of the latter were made. He moved from his estate in West Bloomfield to Virginia. On June 16, 1923, Walter Flanders died from complications following an automobile accident three days prior. He was 52 years old. (Courtesy of Paul Benson.)

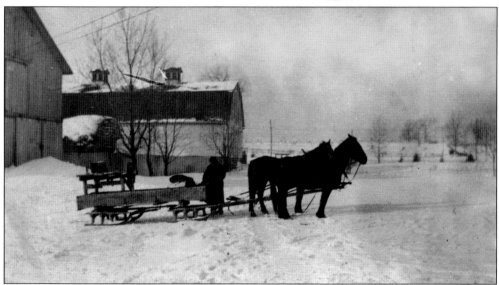

A horse and sleigh are seen here in front of the Doherty barns. Orchard Lake Road is to the right. Draught horses were used for heavy work. The sleigh was an alternative method of transportation in winter months, when snow and ice made travel by wagon and carriage challenging at best. (Courtesy of Molly Rozycki.)

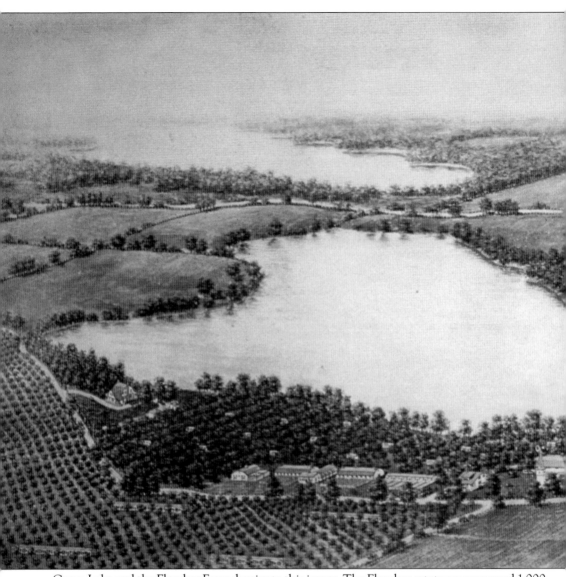

Green Lake and the Flanders Farm dominate this image. The Flanders estate encompassed 1,000 acres, including Green and Flanders Lakes. Walter Flanders, an automobile magnate, first built a home on the south shore of Green Lake. He built his second, a sprawling estate, across the lake. The residence included a garage with a dance hall on the second floor, a turntable for his car to

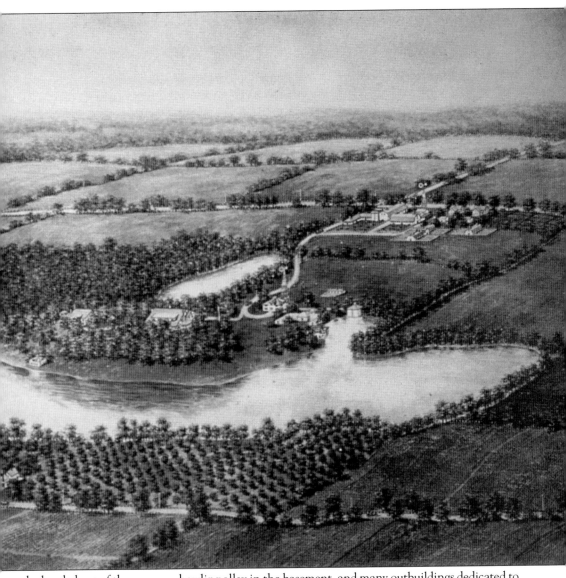

be headed out of the garage, a bowling alley in the basement, and many outbuildings dedicated to farming operations. At one time, he employed 300 to 400 farmhands. Flanders (1871–1923) is best known for developing the automotive assembly line for Henry Ford. (Courtesy of Paul Benson.)

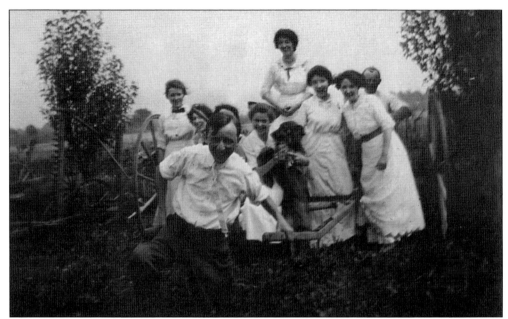

Albert Doherty (front) is shown here with his sister Margaret (rear, far left) and Nick Doherty (rear, far right). This photograph was taken at the Doherty farm on Orchard Lake Road just before World War I. Here, Albert is horsing around, pretending to take the place of a horse. John Doherty started Pontiac Tractor Company before World War II and is said to have invented the turn-on-a-dime turning mechanism for excavating equipment. (Courtesy of Molly Rozycki.)

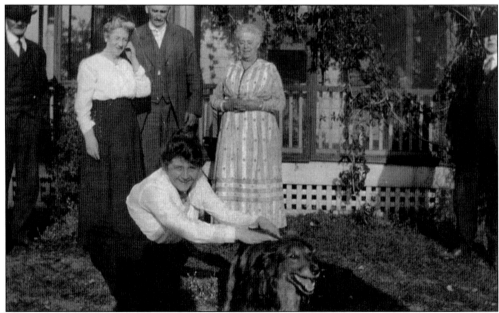

At left, John Doherty, Albert and Nick's father, is shown at the Doherty house with his wife, Mary (or "Minnie"), around 1910. Mary's sister Josephine is with Bob the dog. John and Minnie bought this farm on Orchard Lake Road around 1900, having sold their farm on Pontiac Trail, close to the Emmendorfer House, by Arlene Drive. The farm had over 200 head of dairy cows, some of which were prizewinners. (Courtesy of Molly Rozycki.)

The folks on this milk house roof are, from left to right, Marie McGaffey, Albert Doherty, Marguerite McGaffey, Margaret Doherty, and Frank Doherty. The Doherty farm was known for its prizewinning dairy cows. John Doherty built a little railway from his barn to the interurban rail to transport his milk to market. (Courtesy of Molly Rozycki.)

This steam tractor is at the Wendell Green farm on Fourteen Mile and Halstead Roads. The other Green farm, which produced fruit, was at Orchard Lake and Walnut Lake Roads. A stockpile of hay is seen in the background during thrashing season. The hay was used to feed dairy cows and other livestock. (Courtesy of Molly Rozycki.)

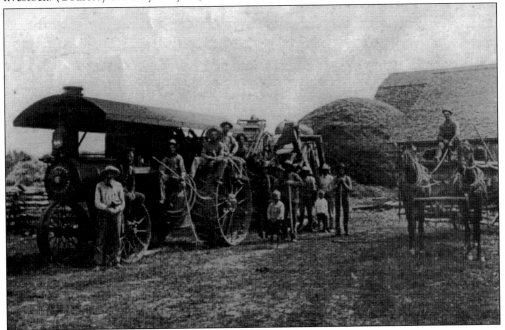

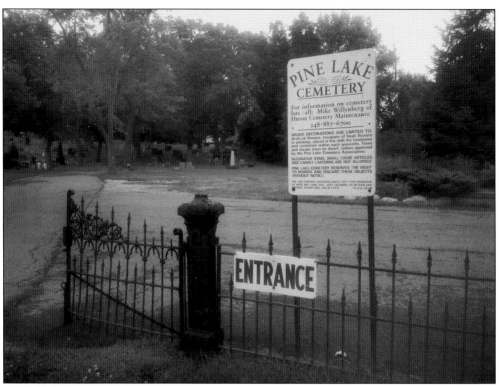

Pine Lake Cemetery is one of the oldest historical sites in the township. Eben Ellenwood, an early township resident who died in 1831, is thought to be the first person interred here. The Ellenwoods were among the earliest European American settlers in the township, establishing themselves on the east shore of Pine Lake. They owned land in that location until the turn of the 20th century. The cemetery is located on Middle Belt Road, just north of Lone Pine Road. (Author's collection.)

HELP WANTED

Applications taken now for Fruit Harvesting on or about September 1st.

Physically fit men, ages 21 to 45, sober and responsible, for full or part time work.

— Register Here Now —

This help-wanted notice indicates the seasonal labor required in West Bloomfield due to the vast acreage of orchards, even into the middle of the 20th century. Before four-lane roads, strip malls, and even the first dedicated library, fruit orchards lined the main and secondary roads in the outlying areas in and around the lakes. Roadside "fresh fruit" stands also dotted the roads. (Courtesy of GWBHS.)

Two

WEST BLOOMFIELD LATER

War drums sounded in 1914, and although formal US involvement in World War I did not come until 1917, West Bloomfield volunteers were hard at work doing their part. The Countryside Improvement Association, founded in 1911, led the effort to supply the Red Cross with canned goods to assist those nations already at war. At its height, volunteers packed and sent 200 cans a day for three successive summers. The police department was established in 1920 with one officer.

In the 1930s, West Bloomfield became the location for an interesting and successful social experiment. Sen. James Couzens obtained federal funds for the creation of a low-income housing project. The residents received home loans in return for using their one-acre or three-quarter-acre parcels to raise food products. This community, Westacres, flourished and is a microcosm of the West Bloomfield of today.

The township bought 99 acres of land in 1973 for the future construction of a civic center. The fire department's emergency medical services began operating on May 1, 1978, with two rescue units and 14 trained personnel.

Halsted Road from Fourteen Mile Road north of Walnut Lake Road was designated a Natural Beauty Road in 1982. A segment of Walnut Lake Road (from Halsted Road to Haggerty Road) was given the Natural Beauty Road designation in 1989.

The new town hall at 4550 Walnut Lake Road opened in the fall of 1989. The police department moved into its building at the Civic Center site in 1990, and the parks and recreation department, which had originated by popular referendum in 1970, moved to its Civic Center location in 1996.

The West Bloomfield Library, established in 1938 by the Keego Cass Women's Club, moved to 4600 Walnut Lake Road on the Civic Center site in January 1984. The Westacres Library, located at 7321 Commerce Road, was purchased by the township in 1965 and was remodeled and expanded in 1985 and 1999. There are six private golf courses in West Bloomfield. There are seven school districts within West Bloomfield Township: West Bloomfield (seven schools), Walled Lake (four schools), Bloomfield Hills (three schools), and Farmington (one school). Pontiac, Birmingham, and Waterford districts have no schools within the township.

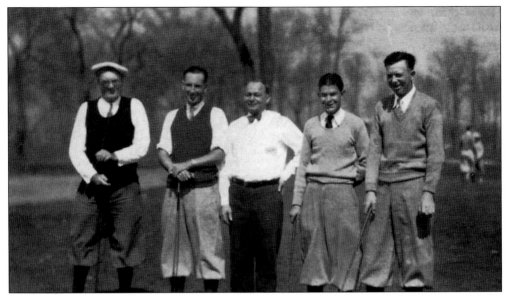

By the 1920s, the Automobile Country Club had become Pine Lake Country Club. Here, Pine Lake golfers pose on the course in the 1930s. They are, from left to right, Ernie Way, Jimmy Anderson, Pete Newman, Dixie Wilkins, and Jock Inkster. Inkster went from caddie master to club professional beginning in 1930. He greeted folks with a Scottish "Hi, laddie." He is probably best known for playing the course regularly using just one club. (Courtesy of Pine Lake Country Club.)

The "Old Pro," as Elmer Prieskorn was known, was Pine Lake Country Club's golfing professional from 1954 to 1979. He is well known for instructing female golfers and pros on the Ladies Professional Golf Association circuit. A retirement dinner was held in his honor, attended by over 500 people, including professional golfers Pat Bradley, Carol Mann, and Kelly Robbins. (Courtesy of Pine Lake Country Club.)

The West Bloomfield Fire Department, established in 1930, was manned by volunteers. In 1932, they responded to 22 house fires, eight grass fires, and one muck fire. They used 4,750 feet of hose, 650 gallons of chemicals, and raised 225 feet of ladder. The original firehouse, pictured here, was located between Willow Beach and Cass Lake Road in Keego Harbor. (Courtesy of Coral Lou Walling.)

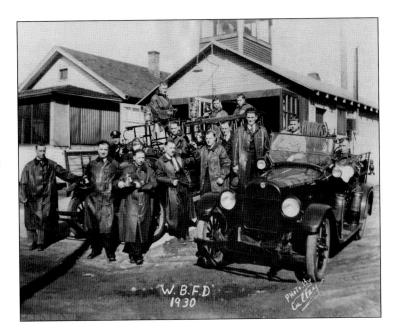

Jane Doherty (second from left) is seen here with her sisters Peggy (far left), Mary (on Blackie, their horse), and Esther (eyeballing the kitten). This photograph was taken at the John Doherty farm. The Doherty girls would walk to school across Green's Orchards. They were not allowed to take apples off the trees, but if apples were on the ground, they could be picked up and eaten. (Courtesy of Molly Rozyckiw.)

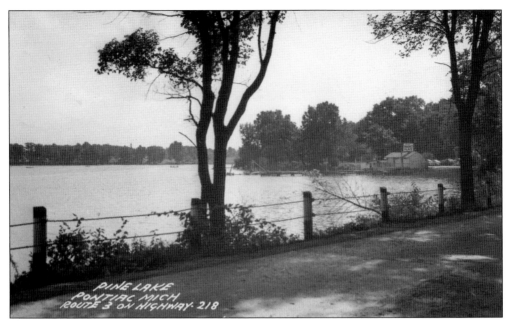

The lakes area in West Bloomfield and surrounding Oakland County had many places to vacation in summer months. Shorty Hook's Place, up the road on the right in this photograph, was for many decades on Orchard Lake Road, facing Pine Lake. Even after the cabins had disappeared, vacationers could still rent a boat and buy bait. The boathouse still remains, but it has been renovated as part of the large housing development that occupies the old property. (Courtesy of Joan Walsh.)

Shorty Hook's nine-year-old boy, Max, won at the Pontiac Skating Carnival, held on Sunday, January 15, 1933. He won the ice-skating free-for-all race in the under-10 category. Max was a student in Mrs. Bachman's 3-A class at Roosevelt School at the time. His parents ran Shorty Hook's Place (pictured) for summer vacationers on Pine Lake. Might Max have won because he grew up on the lake, where ice-skating was akin to walking? Ah, but so did many other kids. (Courtesy of Joan Walsh.)

Orchard Lake Road, seen here looking south at Indian Trail, is the old Algonquin and Ottawa Trail extending from Lake St. Clair to what was later Illinois. It became an early road used by settlers in nearby Pontiac to seek out new stands of timber and to explore outlying lands. When other roads were cut, including Pontiac Trail in 1828 and Commerce Road in 1831, Orchard Lake Road became an even more important link to neighboring communities. There was a tollgate just over the hill, beyond this photograph, until the first part of the 20th century. The road was paved in the 1920s and designated state road M-218. (Courtesy of Joan Walsh.)

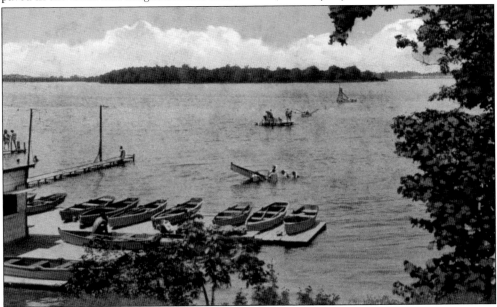

Until the 1980s, visitors could rent a rowboat on this corner of Indian Trail and Orchard Lake Road. This 1920s postcard includes the following note to its recipient: "Hello David! Dick & I are having a dandy time here. We go in swimming every day and tomorrow we are going horseback riding. With Happiest Regards Joyce & Dick S." The postcard is dated August 27, 1928. (Courtesy of Joan Walsh.)

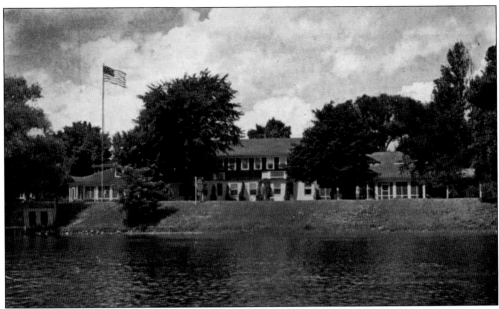

Rotunda Inn was a dining and lodging destination on the north shore of Pine Lake for much of the 20th century. It began as one house before a neighboring house was purchased. The homes were eventually connected as the restaurant business grew. The inn, a location of many weddings and other social events, was known for its excellent brunches. (Author's collection.)

Dinner Menu

SPECIAL APPETIZERS

Jumbo Shrimp Cocktail	.85	Chicken Liver Paste		.65
Marinated Herring	.75	Half Grapefruit		.35
Appetizers from the Smorgasbord with Dinner				1.00

DINNER SUGGESTIONS

Fruit Cup with Sherbet — Tomato Juice
Apple Juice with Sherbet — French Onion Soup with Croutons
Soup du jour

ENTREES

Seafoods

Broiled Whole African Lobster Tail, Drawn Butter	3.95
Broiled Georgian Bay Whitefish, Lemon Butter	3.10
Deep Fried Jumbo Butterfly Shrimp, Rotunda Sauce	3.25
Sauteed Deep Sea Scallops, Tartare Sauce	2.95

Fowl

Roast Young Tom Turkey, Savory Dressing, Cranberry Sauce	3.10
Country Fried Disjointed Young Spring Chicken	2.95
Served Family Style	
Chicken a la King en Casserole, Toast Points	2.50

Chops

Two Broiled Baby Spring Lamb Chops, Mint Jelly	3.75
Grilled Calves Liver, Sauteed Onions	3.50
Two Grilled Center-Cut Pork Chops, Apple Sauce	3.25
Grilled Chopped Sirloin Steak, Mushroom Sauce	2.75
Broiled Ham Steak, Fruited Wine Sauce	3.50

VEGETABLES AND POTATOES
Choice of Two

Whipped Potatoes — French Fried Potatoes — Vegetable du Jour
Baked Idaho Potato, Sour Cream Dressing

CRISP SALADS

Tossed Green Salad — Molded Fruit Salad
Wedge of Crisp Iceberg Lettuce
Rotunda French Dressing — Fruit Salad Dressing
Roquefort or Thousand Island
Ceasar Salad, Ceasar Dressing

☆ ☆ ☆

Choice of Beverage and Dessert

☆ ☆ ☆

Coffee — Sanka — Pot of Tea — Iced Tea — Milk

SPECIALTIES OF THE HOUSE

Choice of Soup or Tomato Juice
Thick Cut of Roast Prime Rib of Steer Beef, Natural Gravy
Baked Idaho Potato with Sour Cream Dressing — Vegetable
Wedge of Crisp Iceberg Lettuce with Choice of Dressing
Beverage and Dessert
3.90

Choice of Soup or Tomato Juice	Choice of Soup or Tomato Juice
Broiled Filet of Mignon with Mushrooms	Prize 14 Ounce Steer Sirloin Strip Steak
Choice of Potato and Vegetable	Choice of Potatoes and Vegetable
Wedge of Head Lettuce	Wedge of Head Lettuce
Choice of Dressing	Choice of Dressing
Beverage and Dessert	Beverage and Dessert
4.75	**5.50**

The food at Rotunda Inn was praised by Duncan Hines, who was famous for rating restaurants across America. The menu was mainstream American in its day, and though the prices here seem unreasonably low, they were on par with other restaurants of its type for the day. Several fires occurred at the restaurant over the years. It was sold and became Charley's Crab in the 1970s. Soon after, a fire destroyed too much of the building for the township to allow rebuilding, as the structure no longer conformed to the residential zoning. (Courtesy of GWBHS.)

Amy and Howard Bloomer were catalysts, along with the Countryside Improvement Association, in establishing state parks in southern Michigan during the early part of the 20th century. Howard, an executive with Dodge Brothers Motor Corporation, convinced the company to donate money for large tracts of land to establish the first state parks in the area. (Courtesy of American Academy for Parks and Recreation Administration.)

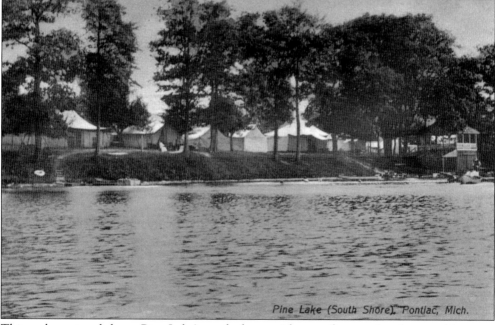

This early postcard shows Pine Lake's south shore, with tents for camping. Later, cabins were built and then condominiums in the 1970s. This spot was a stone's throw from the renowned Interlaken community, which was an inspiration for many summer visitors coming to Pine Lake and the area in general. (Courtesy of Joan Walsh.)

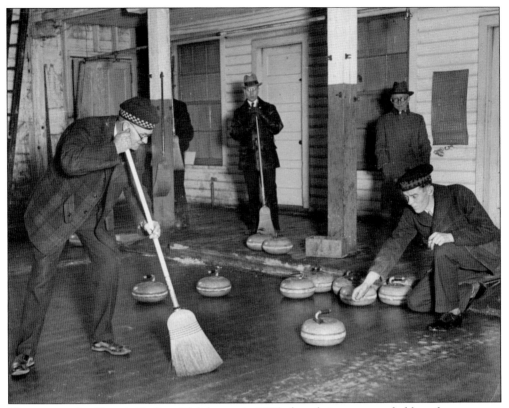

The present-day Detroit Curling Club began in 1885, though it was preceded by other start-ups in Detroit. The early clubs did a lot of curling on the Detroit River and met with clubs from Ontario and the lakes in West Bloomfield. Shown here is one of the early clubs in Detroit that would later move to West Bloomfield. The curling clubs in Detroit were all born of the first club in Orchard Lake, Michigan. The sport of curling brings players together from all walks of life. (Courtesy of GWBHS.)

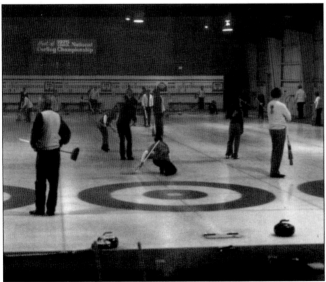

Over the years, the Detroit Curling Club promoted the sport to spawn additional clubs in neighboring communities, with little success. The club had various locations of its own clubhouse. In 1978, a riding stable, Centaur Farms, became available in West Bloomfield, close to the area where curling began in North America. In 1979, it became the new location for the Detroit Curling Club, which would remain there until 1998, as shown here. (Courtesy of Detroit Curling Club.)

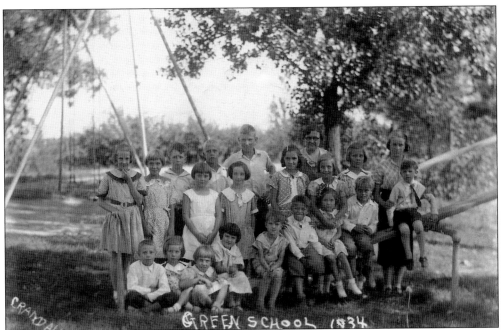

The Green Lake School class of 1934 poses on the playground. The first Green School opened in 1866 on land donated by the Green family on the corner of Green Road and Savoi Trail. The schoolhouse measured 20 feet by 34 feet and included students up to the eighth grade. A second Green School was built in 1948 to accommodate the growing population. That school still exists, next to the current Sheiko School (formerly Green School). (Courtesy of GWBHS.)

Esther (left) and Jane Doherty pose at the playhouse given to them, which stands in front of the house built by Frank Doherty that Albert and Elinor Doherty moved into. Elinor died young from toxemia during pregnancy in 1937. The property was eventually taken by the school district to build Doherty School in the 1960s. (Courtesy of Molly Rozycki.)

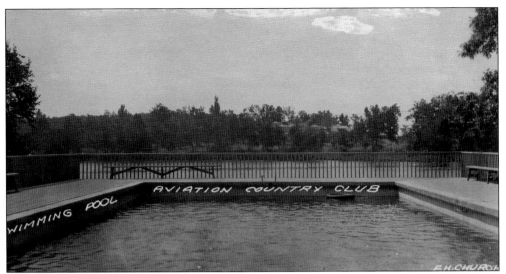

Aviation Country Club was one of several country clubs in the township in the 20th century. The uniqueness of this club was that it had a large airfield for its well-to-do members, such as Eddie Rickenbacker, who could afford to fly in and out or have guests or business associates do the same. Located on the former Flanders estate, the club purchased the site and began operating in 1920, just two years after World War I. The war had put aviation on the map as a reliable and significant means of transportation. It should be noted that roads were extremely poor in remote areas like this. Seen on this postcard is the pool from the Aviation Country Club, looking toward one of the lakes on the property. (Author's collection.)

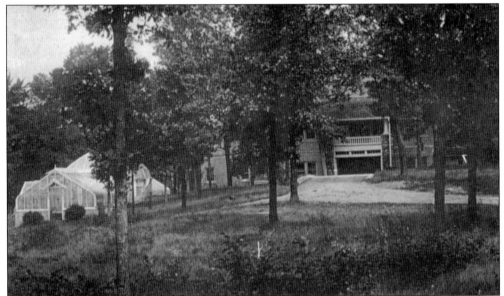

The Flanders garage and conservatory are shown here in their early days. The garage was purchased in 1949 by the Green Lake Association, which represents property owners around the lake. The main house next door became a senior's residence and still operates today. The garage has been preserved in its original state, along with several acres of land around it. Flanders Lake can be seen from the rear of the second-floor ballroom of the garage, where entertaining still takes place. (Courtesy of Paul Benson.)

Roy Fruehauf and Howard Flint, highly successful business owners, had their family homes within earshot of each other in West Bloomfield Township. This advertisement is for a Fruehauf Trailer, used for carrying Flint ink. Fruehauf developed a trailer that increased the capacity of Flint's tankers, substantially garnering their future business for tanker trailers. Flint Ink supplied most of the printing ink across America. (Courtesy of Fruehauf Trailer Historical Society.)

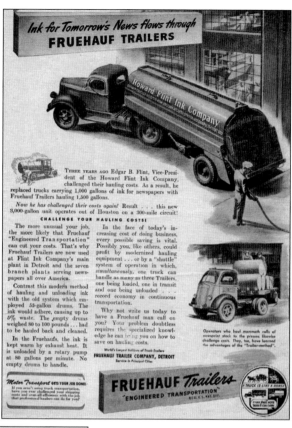

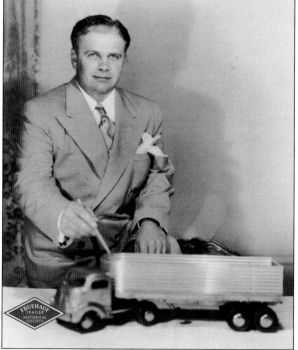

Roy Fruehauf (1908–1965) was the second generation to run Fruehauf Trailer and the first of his siblings to graduate from college. He was president of the company from 1949 to 1958 and chairman from 1958 to 1961. He is credited, along with Howard Flint of Flint Ink, with donating and raising the funds for the monumental Kirk in the Hills Church after it burned down and for the bells for its carillon. (Courtesy of Fruehauf Trailer Historical Society.)

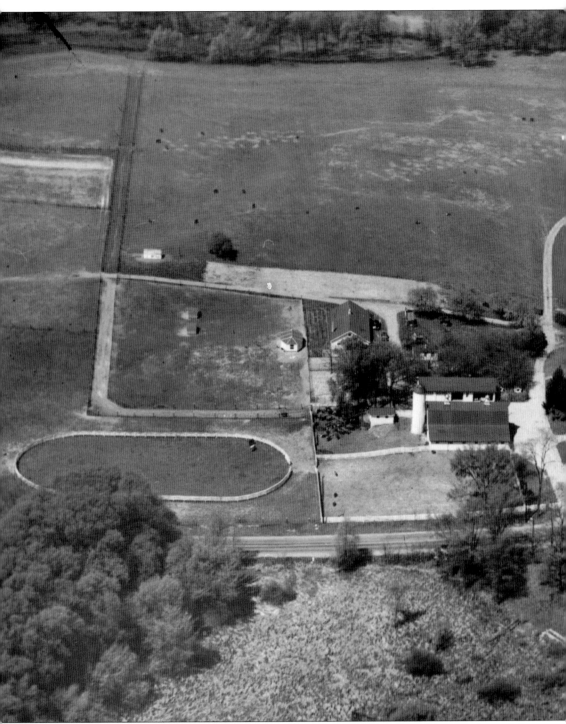

This aerial view of the Fruehauf farm in West Bloomfield, known as Paloma, shows lakes, bridges, and many outbuildings. Roy Fruehauf had several head of cattle on the farm, said to be for personal consumption as much as anything. Fruehauf frequently prepared and packaged fresh beef for friends. When Roy passed away in 1965, Ruth Fruehauf had an addition built onto

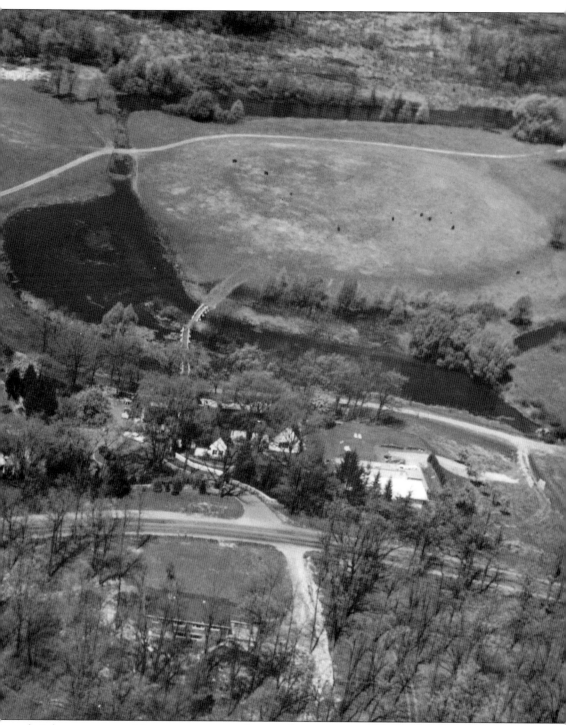

their home as a rental-income apartment. Among the tenants was Punch Andrews, manager of Bob Seger's band. Young Ruth Ann recalls coming home from school on many days as a young girl in the late 1960s to the sounds of Bob Seger and his band practicing. (Courtesy of Fruehauf Trailer Historical Society.)

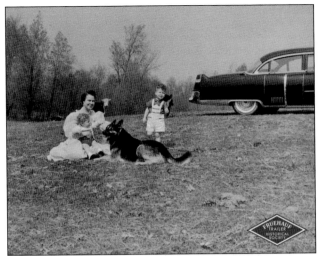

Ruth Horn Fruehauf poses here with her children (from left to right, Ruth Ann, Randy, and Royce) on their farm in the 1950s. Ruth and Roy married in 1950 and, soon after, moved to the farm on Middle Belt Road. Along with her husband, Ruth was extremely active in community charitable causes, and she continued to be after her husband's death. (Courtesy of Fruehauf Trailer Historical Society.)

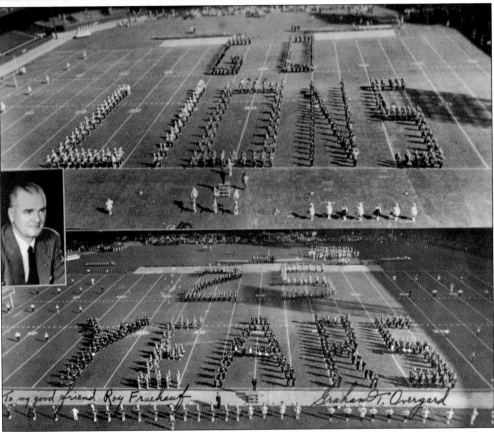

Graham T. Overgard (1903 to 1994) was an American musical composer, conductor, and teacher. For a time, he conducted the Detroit Lions marching band, which no longer exists. A resident of West Bloomfield Township, Overgard lived on a sizeable farm off of Middle Belt Road near Walnut Lake Road. In this photograph, his Lions band performs at Tiger Stadium, which served as the Lions' first professional stadium until the team moved to the Pontiac Silverdome in 1975. It was the first stadium built entirely for the Lions' use. (Courtesy of Fruehauf Trailer Historical Society.)

James Couzens, a former US senator, mayor of Detroit, and Ford Motor Company executive and board member, established the nonprofit Oakland Housing, Incorporated, with a $550,000 donation. The organization sought to build housing for low-income families that would also allow the homeowners to grow their own food on their lots. In this way, a communal environment would be established that would foster financial and moral support among neighbors. It was called Westacres. (Courtesy of Kyle Staulter.)

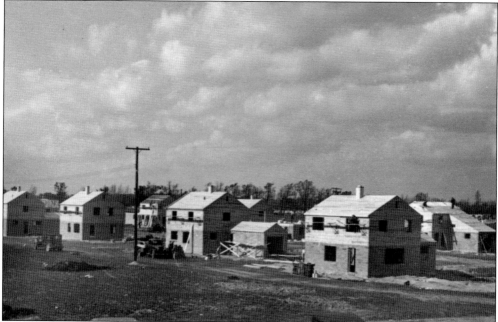

In 1936, Oakland Housing, Inc. purchased 874 acres of land in West Bloomfield Township, Michigan, and began building 140 single-family homes. James Couzens would not live to see them completed. Only once did he visit the site; he was almost turned away by a guard before Couzens convinced the man that he was who he said he was. (Courtesy of Bentley Historical Archives.)

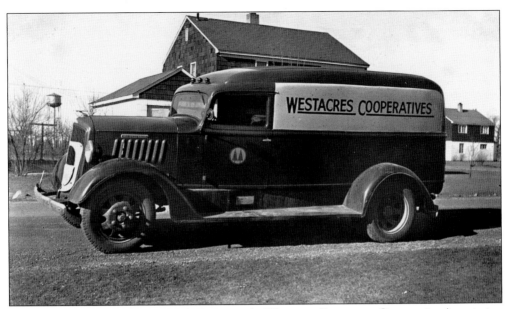

As part of the communal concept of Westacres, the Westacres Consumers Cooperative Association was formed in June 1937 on the heels of the Westacres Credit Union, which was established the previous fall. A variety of goods could be purchased through the cooperative store, including coal at a much-reduced rate. This cooperative truck was available for many community needs. (Courtesy of Kyle Staulter.)

Orchard Lake Community Church pastor Henry Jones (far right) poses with David, Sandy, Bobby, and Harold Welch at their home in Westacres in 1943. Harold and Ruby Welch were among the 59 charter members when the church became part of the Presbytery of Detroit on October 24, 1943. Rev. Barney D. Roepcke was installed as pastor on October 31, 1943. As pastor, Jones was instrumental in the church becoming Orchard Lake Community Church, Presbyterian. (Courtesy of Orchard Lake Community Church, Presbyterian.)

What started as Field Day evolved into Aquacade. In the late 1930s and early 1940s, a summer gathering was held to promote fun. Races of all kinds were held on land and on and in the lake. From egg-tossing to necktie-racing, no age group was left out or immune to the fun. (Courtesy of Kyle Staulter.)

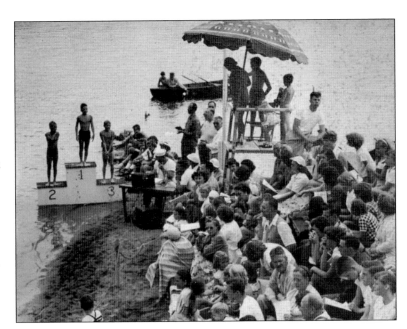

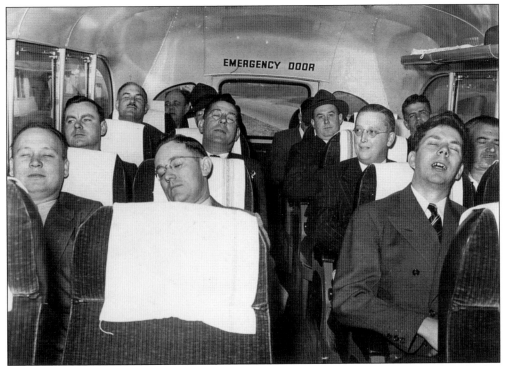

In 1939, Chrysler employees living in Westacres banded together and bought a used Dodge bus to commute to work. Though the first bus was quite outdated and worn, the plan succeeded for many years. Pictured here in no particular order are (front row) Eugene Zipp, Harold Welch, and Jorme Sarto; (second row) Claude Long, Charles Wright, and Don MacKenzie; (third row) Charlie Kurzweil. (Courtesy of Kyle Staulter.)

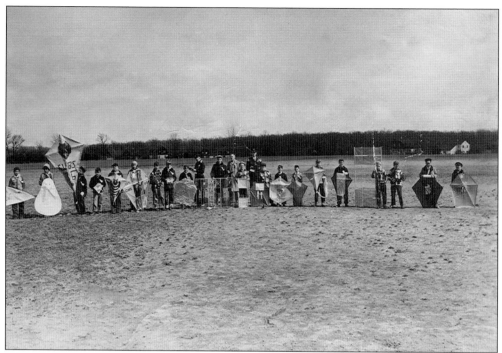

The first scout troop was organized at Westacres by its fire department and was christened the James Couzens Boy Scout Troop. Charles Wright was its first scoutmaster. This photograph shows Cub Scouts in what appears to be a kite-making and kite-flying contest. The boy with the large kite at left is Greg Willihnganz. (Courtesy of Kyle Staulter.)

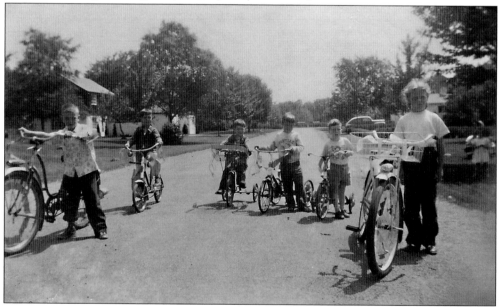

Westacres offered lots of opportunities for neighbors to get out and meet each other. Here, kids with decorated bikes ride in, or prepare for, the Aquacade parade. The tradition began in 1961 and went on for 25 years. The Aquacade was held the first weekend in August, and residents of the community planned their lives around it. (Courtesy of Kyle Staulter.)

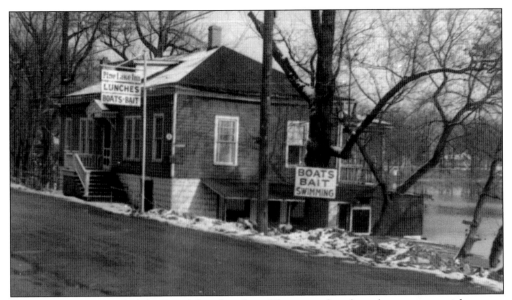

Pine Lake Inn succeeded the Interlaken Landing. The resort hotels and camps were either gone by this point or not relying on water shuttles to take visitors to the opposite shore of the lake. Bill Periard Jr. was the second generation of his family to run the business, which included two living units, a boat livery, diving instruction, and gas pumps for boats. (Courtesy of Mark Periard.)

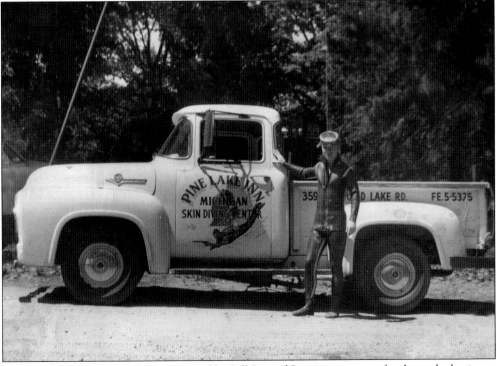

This truck for the Pine Lake Inn, owned by Bill Periard Jr., was necessary for the scuba business. In the 1950s, police and sheriff departments did not have a dive team. Periard and his coworkers, including Shorty (pictured), were called on search missions when a person drowned in a nearby lake. Periard also ran a scuba-diving school from the inn. (Courtesy of Mark Periard.)

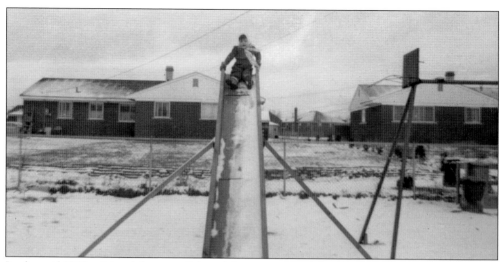

In the mid-1950s, this subdivision, Sylvan Manor, came to life. There was such a great need for postwar housing for veterans and their families that neighborhoods like this sprang up all across America. The subdivision had its own dentist and doctor offices, bowling alley, drugstore and soda fountain, grocery store, church, barbershop, and beauty shop. Sylvan Manor was five minutes from downtown Pontiac, the destination city in Oakland County that reached its zenith in the 1960s. Here, Brenda Sweeney is about to ride the slide in the winter of 1956. In the early 1960s, two houses on this street had bomb shelters installed in their backyards. The shelters doubled as storm shelters, as virtually all of the houses had no basements but, instead, slab foundations. (Courtesy of Brenda Sweeney Farner.)

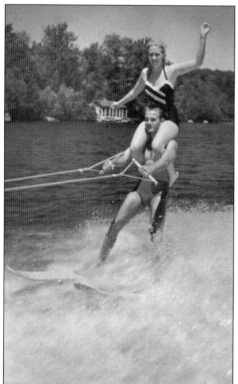

Waterskiing took hold in West Bloomfield unlike in any other place in the postwar United States, except possibly Cypress Gardens, Florida, the capital of acrobatic waterskiing. Here, Jimmie and Bernadette show off for friends on Walnut Lake in the late 1950s. Slalom skiing has been, and still is, most popular, along with wakeboarding. Popular slalom skis in the 1950s and 1960s included Cypress Garden, Lund, Northland, and Chuck Stearns. Later, O'Brien and Connolly skis became popular. There is still a ski school on the west end of Pine Lake. (Author's collection.)

The housing explosion that began after World War II did not slow down in the 1960s. This advertisement for Pine Lake Estates subdivision, in West Bloomfield Township, was aimed at middle-aged families that were wanting to step up to their second or third home. Split-level and Colonial floor plans were most popular. Lake privileges on Pine Lake came with every house in the neighborhood. (Courtesy of John and Patty Hartwig.)

For People Going Places
who require the "right" address

Pine Lake Estates

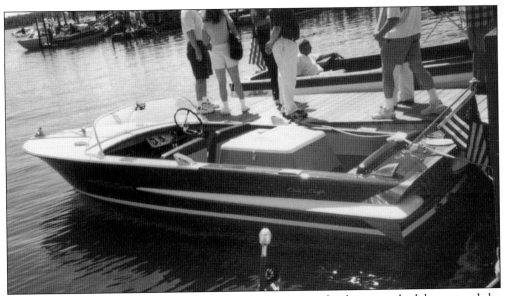

This 1965 Chris Craft from Pine Lake was one of many wooden boats on the lakes around the township. This Holiday, Super Sport model is 18 feet in length and has a Chevrolet 283 V8 engine. If the engine was started before the engine cover was lifted, in order to disperse gas fumes in the bilge, the boat could blow up, as one young boater discovered after his father's boat burned to the water line. No one was hurt, but he did not ski much that year. (Author's collection.)

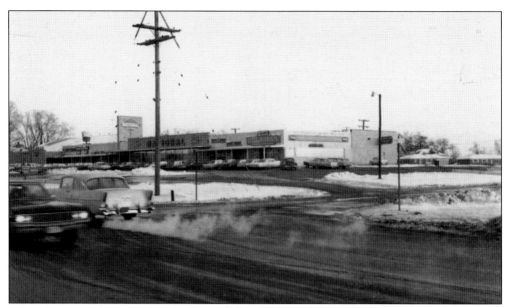

Sylvan Center sprang up with the adjacent Sylvan Manor subdivision, which provided housing for many World War II veterans and their families in the 1950s. This early-1960s photograph shows the grocer National Foods and the dime store Ben Franklin next door. Kentucky Fried Chicken was just beginning as a national franchise. The drugstore on the right had a soda fountain when it opened. Sylvan Lanes bowling alley, on the left end, completed the strip mall. (Courtesy of Jan Morrill.)

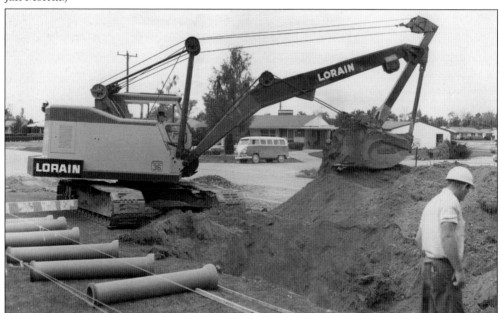

This subdivision was built where a tamarack forest once thrived. The land was flat and wet, so it had to be drained before scores of single-level houses on slab foundations were built in the 1950s. In this 1960s photograph, a water line is being installed for future apartments on Woodrow Wilson Boulevard. Note that the excavator, then called a backhoe, is not hydraulic but powered by cables despite being brand new. J.C. Branscomb is the operating engineer. (Author's collection.)

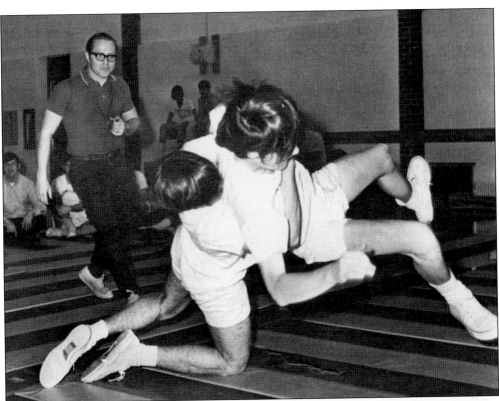

West Hills Junior High School, in West Bloomfield Township, is within the Bloomfield Hills School District. Here, Barry Crowe, the boys' gym teacher, referees as Wally Mayer takes down Jake Jacobsen during gym class. Crowe was also the wrestling coach at Andover High, responsible for many winning seasons there. West Hills opened in 1967. (Author's collection.)

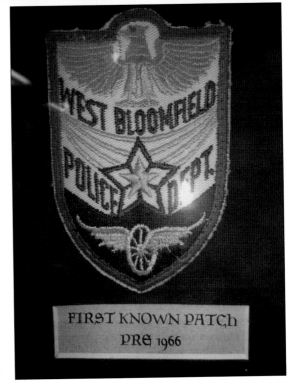

FIRST KNOWN PATCH PRE 1966

The West Bloomfield Police Department began officially in 1952. This is the first police patch known to be used by the department. At that time, the department consisted of a chief of police and two officers. As of 2002, the department comprised a chief of police, one captain, five lieutenants, 12 sergeants, and 55 officers. (Courtesy of West Bloomfield Police Department.)

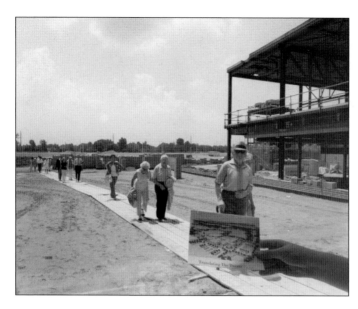

The Jewish Community Center is pictured here under construction. Ground was broken in the summer of 1973 for the new facility. Present at the ceremony were center executive director Irwin Shaw, president Richard Kux, and Mandell "Bill" Berman. The center, located at the corner of Drake and Maple Roads, is an outgrowth of the Oak Park Center. It is open to the entire community. (Courtesy of Leonard N. Simons Jewish Community Archives.)

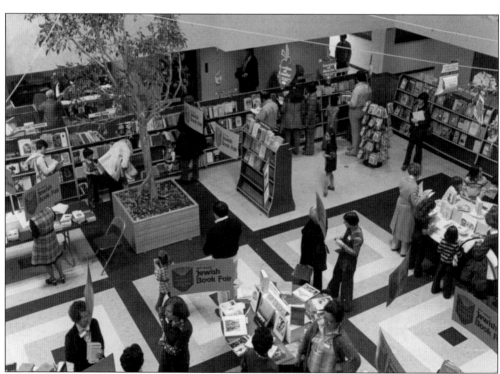

In 1976, the Jewish Community Center held its annual book fair in West Bloomfield for the first time. The 63rd annual book fair was held in 2014. The Jewish Community Center of Metropolitan Detroit's Annual Book Fair is a community-wide cultural and literary event, attracting a large and varied audience of more than 20,000 people of all ages. It is the oldest and largest Jewish book fair in the nation. (Courtesy of Leonard N. Simons Jewish Community Archives.)

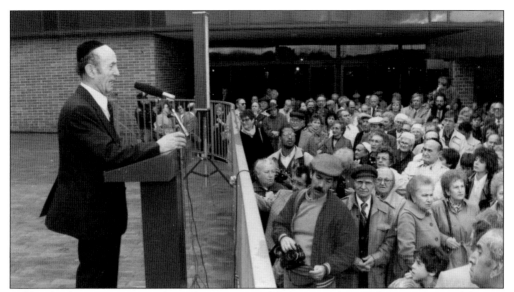

Rabbi Charles Rosenzveig speaks at the opening and dedication of the Holocaust Memorial Center, America's first "free-standing" Holocaust museum, in September 1984. Rabbi Rosenzveig and his wife, Helen, are credited with spearheading the creation of this extremely significant museum and educational center. It was 20 years in the making, from conception, planning, and fundraising to opening. Originally located on the Jewish Community Center campus in West Bloomfield, the museum relocated to a new facility in Farmington Hills several years ago. (Courtesy of Holocaust Memorial Center.)

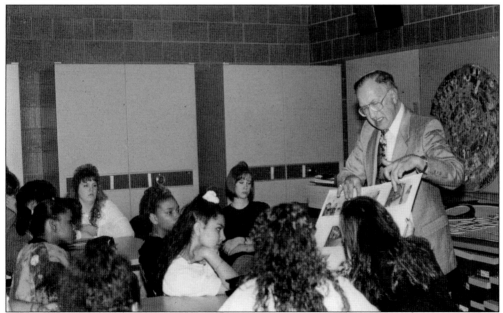

When the Holocaust Memorial Center opened, one of its unique features was that it gave access to visitors to listen to the stories of living Holocaust survivors. Here, survivor Martin Lowenberg shares his personal story with a group of students. Each tour of the center, led by trained docents, culminated with a survivor sharing his or her story with the group. (Courtesy of Holocaust Memorial Center.)

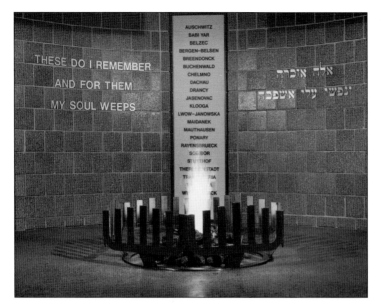

This is the memorial flame at the Holocaust Memorial Center in West Bloomfield at the time of its opening in 1984. "If all the oceans and all the lakes and all the rivers would be made out of ink, it can't describe the catastrophe of what happened to the Jewish people," said Mayer Lebovic, a Holocaust survivor. (Courtesy of the Holocaust Memorial Center.)

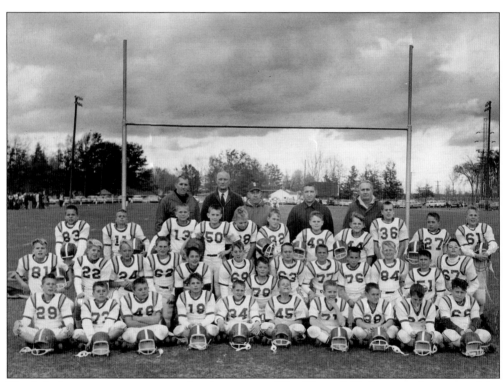

The baby-boom generation was no less booming in West Bloomfield than in other areas of the country. Lakeland Athletic Association was created to provide opportunities for boys to play baseball and football at an age when no other opportunity existed. This photograph shows the Lakeland Lakers freshman team at the end of the 1965 season at the old West Bloomfield High School field, located in Keego Harbor on Summer Street. Among the coaches are Wes Roberts, Herb Cooley Sr., and Red Morgan. (Author's collection.)

Three

CITY OF
ORCHARD LAKE VILLAGE

Orchard Lake is a kettle lake comprising 788 acres in south-central Oakland County. A kettle lake is a depression in the earth that was created by partially buried glacial ice blocks and became filled with water after the glacial ice melted.

The city of Orchard Lake Village, which has a current population of 2,375 residents, became a city in 1964. It is home to SS. Cyril & Methodius Seminary, St. Mary's Preparatory, Orchard Lake Schools, Orchard Lake Community Church, the Orchard Lake Country Club, and the Pontiac Yacht Club. The seminary and schools, both founded in 1885 in Detroit, share the site of the former Michigan Military Academy. Orchard Lake Community Church was dedicated in 1874 and celebrated its 140th anniversary in 2014. Orchard Lake Country Club dates to 1926.

A stone monument near the junction of Commerce Road and Indian Trail Road marks one end of a trail between Mount Clemens and Orchard Lake. It commemorates the great Chief Pontiac and his warriors, who are said to have come here after the Battle of Bloody Run, fought during Pontiac's rebellion and siege of Fort Detroit in 1763.

James Dow was among the first purchasers of land in Orchard Lake, having come to the area in 1830. He eventually came to own Apple Island, a 37-acre, unspoiled island in the middle of the lake. Native Americans, who inhabited the island as long as 2,000 years ago, reportedly referred to the area in their language as "apple place." Willis C. Ward, a lifetime resident of Orchard Lake from 1862 to 1943, was largely responsible for preserving its natural beauty. He came into possession of Apple Island around the time of World War I. After Ward's death in 1943, Apple Island was conveyed to his children, Marjorie Ward Strong and Harold Lee Ward. Upon Ward Strong's death in 1970, the island was deeded to the West Bloomfield School District to be used as an educational nature center.

The island's archeological significance has led to an effort by the Greater West Bloomfield Historical Society to have it placed in the National Register of Historic Places.

Francis A. Emmendorfer came to the United States from Germany in 1852. In 1857, he moved to West Bloomfield. This photograph of the first version of the Emmendorfer house, built in the 1830s by William Gilmour, shows the ornate detail on the main entrance porch and the house in general. The formality of the dress and pose suggests a photograph by appointment. The house's history reputedly involves the Underground Railroad. Gilmour was a founding member of the Orchard Lake Curling Club in the 1830s. (Courtesy of Detroit Public Library, Burton Historical Collection.)

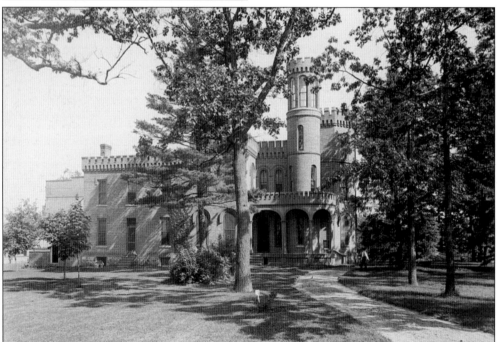

"Copeland's Castle," built in 1858, is the oldest structure on what is now Orchard Lake School's campus. In 1872, General Copeland moved out of his home on Orchard Lake and with partners opened the Orchard Lake Hotel using the castle and adjacent Victorian house for the hotel. Within five years, the new business was broke, the hotel closed, and the entire campus was sold to a group that established the Michigan Military Academy. The main house's architecture is distinctly military in nature and thus was particularly attractive to those starting a military school. (Courtesy of Library of Congress.)

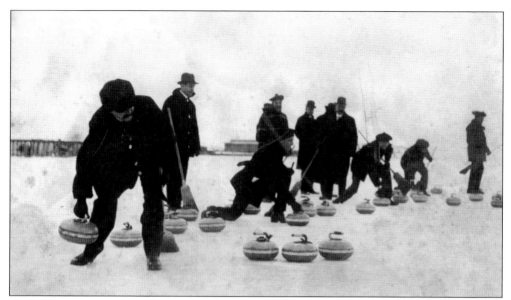

Curling on Orchard Lake began as early as 1831, when the Orchard Lake Curling Club was formed. It is said to be the first such club in the United States. The founders were Scotsmen from around Orchard Lake and nearby Pontiac, including Peter and George Dow, William Gilmore, James Miller, William Walls, James Burns, D. Fillans, John P. Wilson, William Thomson, and O. Robinson. This photograph depicts early curling on Orchard Lake. (Courtesy of GWBHS.)

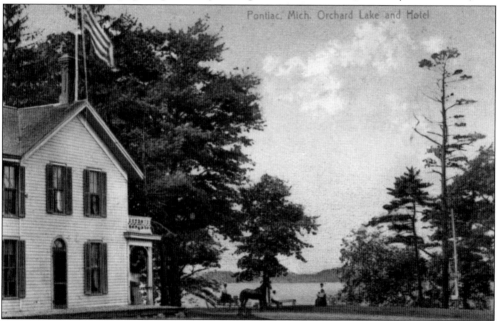

Orchard Lake House was the first name of this hotel and summer resort, built in 1854. It later became the Orchard Lake Hotel when a resort of the same name across the lake ceased to exist. It was perhaps the earliest hotel or lodge outside of Pontiac in the lakes area. In 1938, the hotel was demolished, and a new city hall was erected on its foundation for the village of Orchard Lake. When the village, which became a city, built a new civic headquarters in 1987, the old hall became the museum for the Greater West Bloomfield Historical Society. (Courtesy of Joan Walsh.)

David Ward was a lumber baron, investor, and community and civic leader, as well as a physician. He married Elizabeth Perkins of Richmond, Michigan, in 1850. Their land holdings around their home on Cass Lake amounted to about 300 acres. The Ward family married into the Palmer family of Pontiac, who were well off in their own right. The Ward name appears on streets and in community resources in several towns. (Courtesy of Earl Partica.)

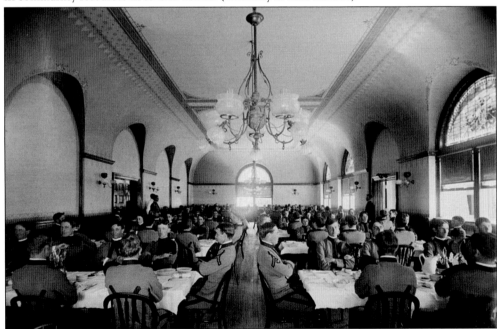

There was no cross talk allowed between tables at the Michigan Military Academy. Cadets were not allowed to talk to the waiters, some of who were African American, or to take food out of the commissary. The dining hall was just as structured as the rest of the day. No food was to be wasted. The bakery was in the basement, and commissary and kitchen workers lived upstairs. (Courtesy of Library of Congress.)

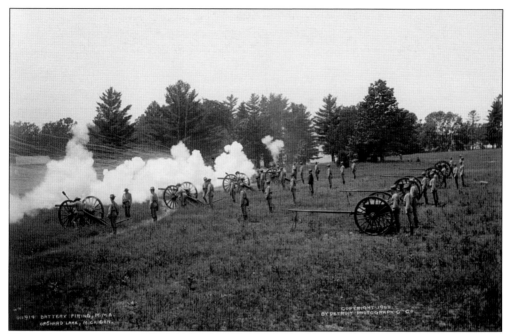

The cadets were always pulling pranks. In one instance, they removed one of the "Napoleon" guns (shown here) from the artillery park, loaded it on the scow (ferry to Apple Island), hid it there, and returned to the school. There, they placed a calf in the adjutant's office and set up a poultry yard in the quartermaster's headquarters. (Courtesy of Library of Congress.)

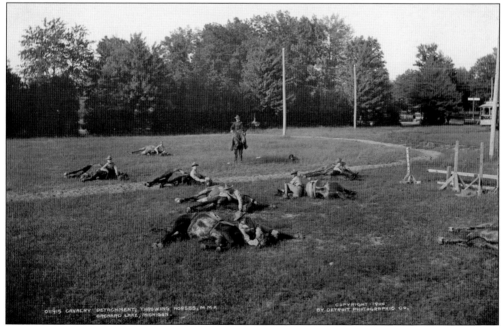

This military exercise was taught to save a soldier's life. When the command was given to "throw horses," a cadet was to manage his horse so as to have it lay on the ground, then taking cover behind the horse. In this way, the soldier used the horse as cover from incoming rifle or artillery fire. (Courtesy of Library of Congress.)

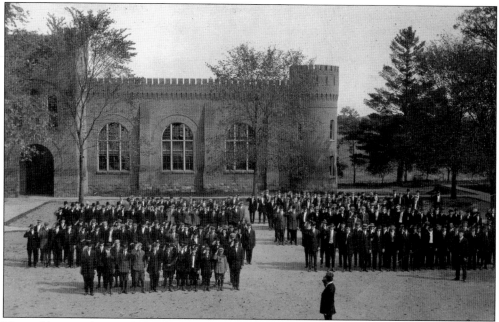

Here, old-timers from early Michigan Military Academy days reunite. They are congregating in what was referred to as the "area," equivalent to a town square. The primary buildings were laid out around this open area to facilitate a space for training cadets in military drills and exercises. (Courtesy of Orchard Lake Schools.)

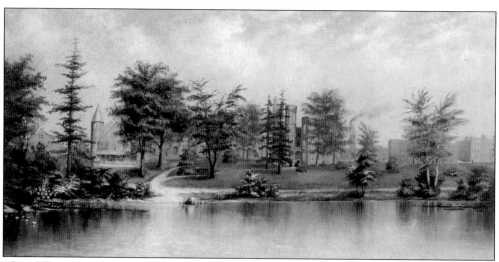

This idyllic image of the Michigan Military Academy amplifies the serene quality of the location. While serenity was not necessarily an asset for a military academy, it was definitely seen as a perfect ingredient for the Polish Seminary when it located here in 1909. Even today, visits to the grotto on a summer's night make one feel quite removed from the densely populated suburbs of Oakland County. (Courtesy of Orchard Lake Schools.)

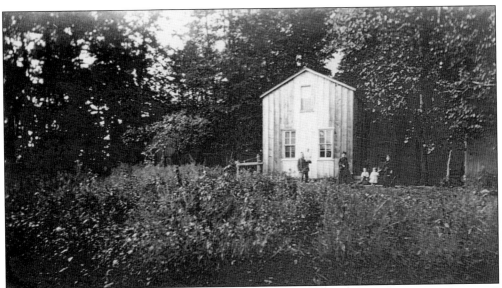

Winfred Hamlin was a caretaker on Apple Island. He cared for eight summer cottages, as well as other buildings, gardens, and boats. He later became the caretaker for Mr. and Mrs. Albert Kahn's summer home on Walnut Lake, ultimately having a home in Sylvan Village in his later years. (Courtesy of GWBHS.)

Forest, son of Colin and Caroline Campbell, was an avid outdoorsman and a proficient businessman and sailor. He loved living on Orchard Lake in the summers. He had a sailboat called *Sheila*. The Campbells owned Apple Island from 1856 to 1915. Forest's cottage was on the east end of the island. The icehouse was just around the east end, on the southeast corner. (Courtesy of GWBHS.)

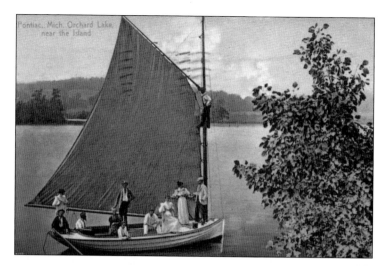

Orchard Lake was and is a great lake for sailing. There are many photographs of early sailing craft on the lake in existence, such as this one. The corner of Orchard Lake Road and Indian Trail was a convenient launching site and a popular bathing beach for many decades, where this image was taken. (Courtesy of GWBHS.)

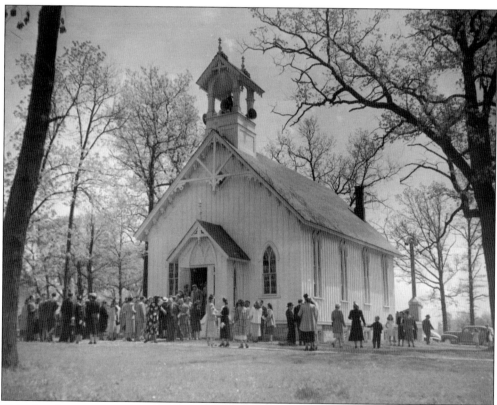

This church service is taking place in the 75th year of the Church of the Wildwood. Opened in 1874, it was a chapel primarily for summer residents. Previously, church services were held on Apple Island at the Campbell summer home. When nearby Westacres subdivision was built in 1936, residents needed space for a Bible school, which the church provided. The two groups united, facilitating the name change to Orchard Lake Community Church. By 1943, the word "Presbyterian" was added. (Courtesy of Orchard Lake Community Church, Presbyterian.)

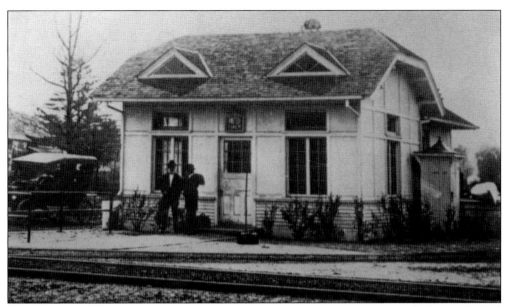

The interurban made a large, triangular route from Detroit to Pontiac, then to Sylvan Lake and Keego Harbor, and to Orchard Lake, where this station was located. From there, the interurban went to Farmington and back to Detroit. Though recreational users headed to the lakes made the interurban profitable for a time, it also provided transportation for workers and transported freight. (Courtesy of Joan Walsh.)

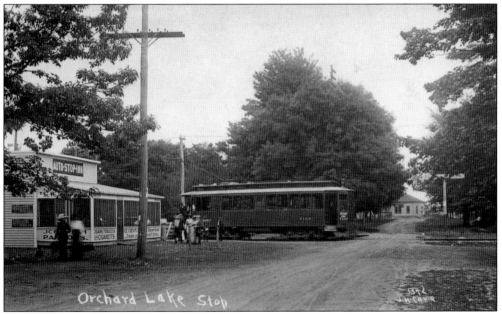

Where Seminary Road comes out to Orchard Lake Road, there was a lot going on in the early 20th century. The seminary had located to Orchard Lake in 1909. The electric railroad, or interurban (later the Detroit Urban Railroad), came through this spot, along with the Michigan Air Line Railroad, bringing tourists, students, and campers to the lakes via rail. In addition, the main roads brought visitors from Pontiac. Nearby ferry landings could accommodate those arriving at their summer destination by water. (Courtesy of Joan Walsh.)

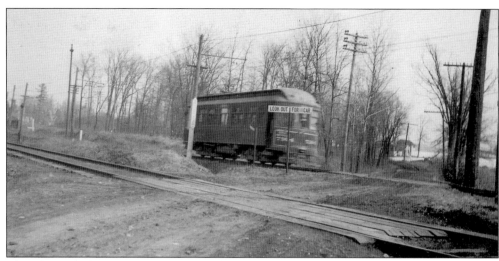

Those living in the rural lakes areas could not take anything for granted anymore, as the warning sign seen here suggests. A man crossing this track was killed by an interurban electric streetcar. Though the electric cars ran year-round, they did so much more frequently in summer months. They took men to work at the factories in Pontiac and delivered mail and freight to business and residences. (Courtesy of Joan Walsh.)

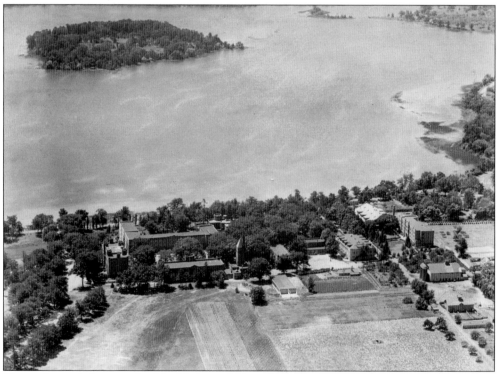

This early aerial photograph of the Michigan Military Academy, later Orchard Lake Schools, looks toward Apple Island. Academy buildings included the "castle," academic building, cadets' barracks, quartermasters' building, gymnasium, commissary, engine house, residence of chaplain, two horse barns, officer of the day's building, quartermaster's residence, icehouse, riding hall, blacksmith shop, cavalry stable, cattle barn, tool house, and hospital. (Courtesy of Joan Walsh.)

Fr. Joseph Dombrowski founded SS. Cyril & Methodius Seminary in 1882. He said, "Value for a nation resides in education and virtue—a people with virtue—a people with understanding and virtue based on religion. We shall arrive at that stage only through our various institutions, which will cultivate and sustain religion and education." (Courtesy of Orchard Lake Schools.)

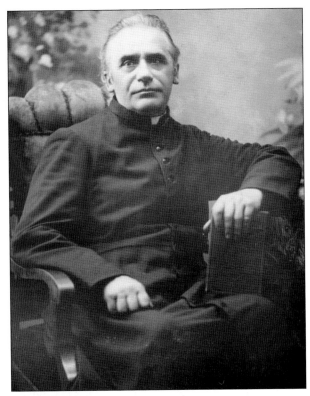

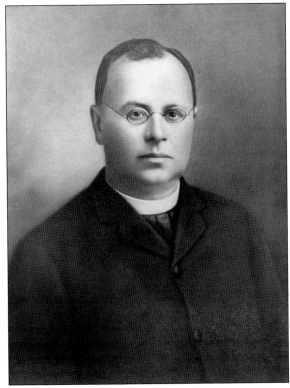

Fr. Witold Buhaczkowski succeeded the Reverend Joseph Dombrowski at the seminary in Detroit. The continued and exponential growth of the school required a new location, with plenty of room for expansion. Using his own money and that of friends, Rector Buhaczkowski made a down payment of $33,000 to acquire the Michigan Military Academy on Orchard Lake in 1909. (Courtesy of Orchard Lake Schools.)

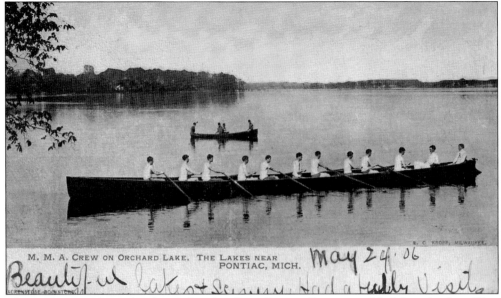

M. M. A. CREW ON ORCHARD LAKE. THE LAKES NEAR PONTIAC, MICH. *May 24. 06*

Beautiful lake + scenery. Had a lovely Visit.

The Michigan Military Academy's founder, Capt. Sumner Rogers, modeled the school on West Point, America's premier military academy located on the Hudson River in New York State. Like other preparatory schools in the Northeast, West Point has a rowing team. The Michigan Military Academy's rowing team is pictured here in 1906. Orchard Lake School's preparatory school has a rowing team. The legacy continues. (Courtesy of Geoff Brieger.)

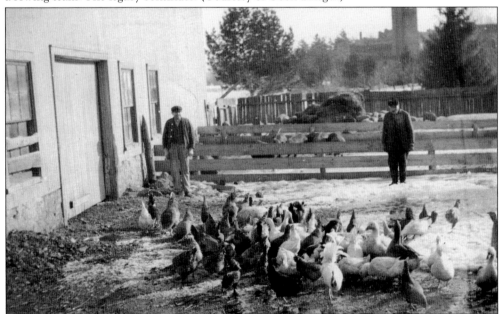

When the seminary bought the military school in 1909, it embarked on an endeavor to grow food for the school, including crops and livestock, in order to achieve self-sufficiency. Polish immigrants had been able to mingle with others from their home country in neighborhoods in Detroit and Hamtramck. Now, the establishment at Orchard Lake gave Poles a new place in Michigan to settle, explore, and find other Polish-speaking newcomers. Many Poles also immigrated to Michigan's thumb area. (Courtesy of Orchard Lake Schools.)

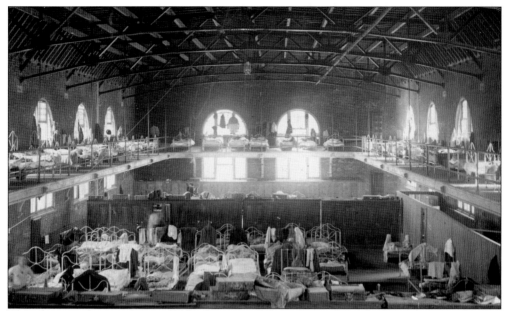

This photograph was taken in 1915, when two of the military classes had to move into the gym for reasons unknown. While there, the groups from the two graduating classes were merciless with each other, playing practical jokes and requiring constant intervention from the prefect. The gym was otherwise used for basketball and intramural activities. It was built in 1895 and designed after the gym at West Point. (Courtesy of Orchard Lake Schools.)

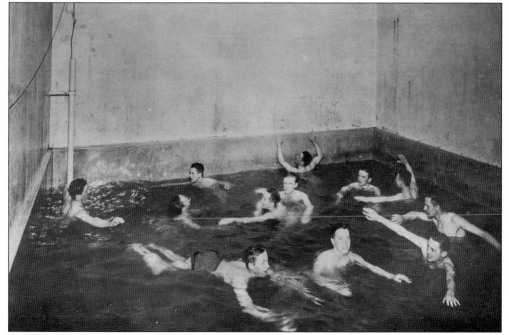

The vastness of Orchard Lake provided the best place for seminary and preparatory students to swim in warm months. But, what about the other three seasons? Apparently, that was not a problem, as indicated by these swimmers in an indoor pool. It appears very small and unconventional. The pool's location on campus is not known. (Courtesy of Orchard Lake Schools.)

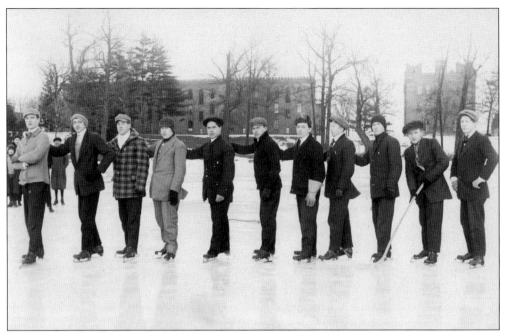

The lakes area provided opportunity for all kinds of activities year-round. In the winter, boys and girls were sliding on ice as soon as they could stand without breaking through. St. Mary's hockey team also took advantage, using the lake as their rink. Orchard Lake Schools now has a professional-size hockey rink at Dombrowski Field House. (Courtesy of Orchard Lake Schools.)

The following passage is excerpted from *Lake Reflections* yearbook for the class of 1934: "A student at St. Mary's can study without being disturbed. Furthermore, the lake and the woods provide for the simple pleasures which one best enjoys, a swim or rowing or fishing in the lake, a walk through the woods there one can enjoy and appreciate, also marvel at the beauty and wonders of nature." (Courtesy of Orchard Lake Schools.)

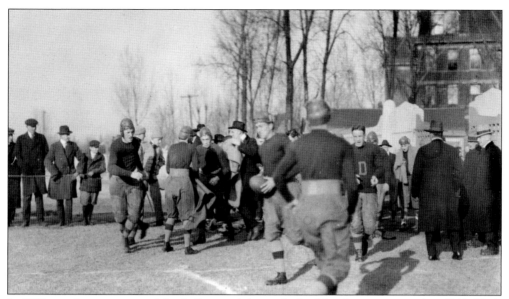

In 1912, seminary-sponsored football ceased due to lack of funding; it resumed in 1931. High scholastic standards were required for a student to be eligible to play. Just three years after the return of the sport, St. Mary's won the Michigan-Ontario Collegiate Conference title under Coach Phil. (Courtesy of Orchard Lake Schools.)

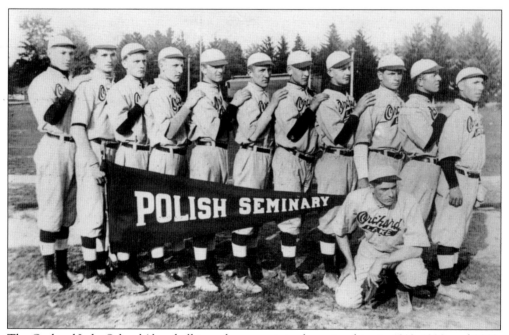

The Orchard Lake Schools' baseball team has won state championships in 1913, 1998, and 2003, and it was the state runner-up in three years. The prep teams have seen three of its members go on to play major-league baseball: Joseph Peplowski, class of 1913, Detroit Tigers; Jim Paciorek, class of 1978, Milwaukee Brewers and Seattle Mariners; and Mike Ignasiak, class of 1984, Milwaukee Brewers. (Courtesy of Orchard Lake Schools.)

"The mission of Cyril and Methodius, two brothers who were immigrant missionaries to the Slavic peoples, inspires us to be a home for newcomers, both clergy and lay ministry students, who value the multicultural environment of the U.S. Catholic Church." This excerpt is from the "Development Campaign" by Chancellor Whalen for the Orchard Lake Schools. (Courtesy of Orchard Lake Schools.)

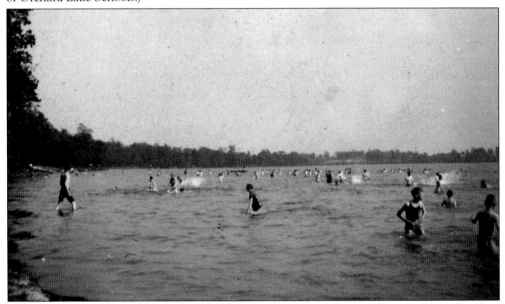

The Michigan Military Academy and St. Mary's Preparatory brought an endless supply of adolescent boys and young men to the shores of Orchard Lake. What better location for unbridled energy than this setting? Swimming, fishing, boating, and wintertime activities provided constant recreation, as seen here. The academy had a rowing team, as does the preparatory. (Courtesy of Orchard Lake Schools.)

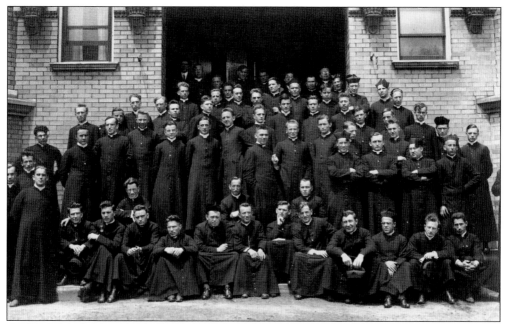

Archbishop Adam Cardinal Maida of Detroit said, "The Orchard Lake Schools began in 1885 with the establishment as a seminary whose mission has been sustaining the Catholic faith tradition of Polish immigrants. Over the years, it has expanded to include the three current schools that educate future leaders from all cultures and backgrounds." Maida was a member of the class of 1948 at St. Mary's Preparatory. He attended St. Mary's College (1948–1950). This early photograph was taken at the seminary at Orchard Lake. (Courtesy of Orchard Lake Schools.)

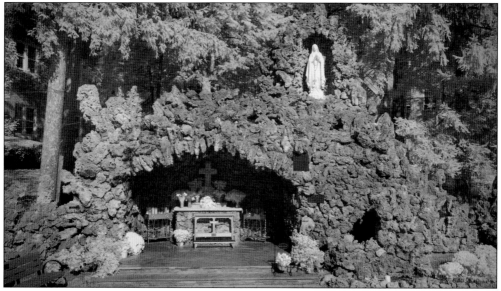

According to the "Development Campaign" for the Orchard Lake Schools: "SS. Cyril and Methodius Seminary is a fully-accredited member of the Association of Theological Schools. It is under the supervision and leadership of the Archdiocese of Detroit, but is one of only a few non-diocesan supported Roman Catholic seminaries in the country." Shown here is the grotto at St. Mary's, a community landmark for decades. (Courtesy of Joan Walsh.)

His Eminence Cardinal Karol Wojtyla visited St. Mary's in 1969 and 1976. He is seen here on one of those visits. He was elected pontiff and became Pope John Paul II two years after his last visit. "If the Orchard Lake Schools did not exist, it would be necessary to establish them," Pope John Paul II said. (Courtesy of Orchard Lake Schools.)

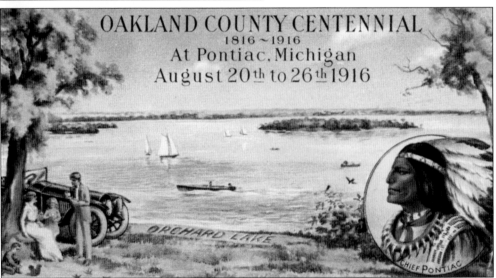

In 1916, Oakland County celebrated 100 years since its establishment. Pontiac was settled two years after the county's founding, and two years after that Pontiac became the county seat. In Oakland County's centennial year, a marker was placed on the corner of Indian Trail and Pontiac Trail by the Countryside Improvement Association to designate the end of the Indian trail from Mount Clemens to Orchard Lake. The marker still stands. (Author's collection.)

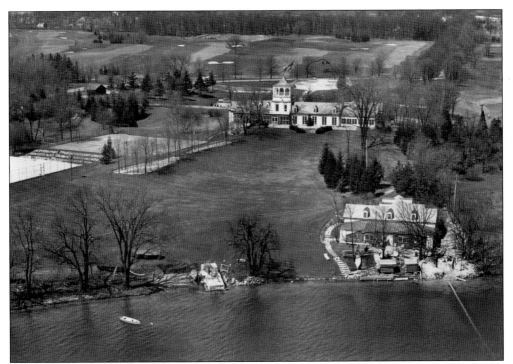

The Orchard Lake Country Club was founded in 1926. Mr. and Mrs. Willis C. Ward and their daughter and son-in-law, Mr. and Mrs. Frederick S. Strong Jr., donated 175 acres of land with 200 feet of Orchard Lake frontage for the creation of a golf and country club. Willis Ward was the club's first president. The membership fee was $500. But, in two years, it jumped to $1,500. (Courtesy of Orchard Lake Country Club.)

Orchard Lake Country Club had golf and sailing as its first sports. The club's lakeside view is shown here. Construction on the golf course began immediately after the club opened in the spring of 1926. The course opened for play in August 1927. In 1928, the first clubhouse was built at a cost of $90,000, and membership fees increased another $500. At the time, the club had 300 members. In 1930, the beach house (pictured) was built. (Courtesy of Joan Walsh.)

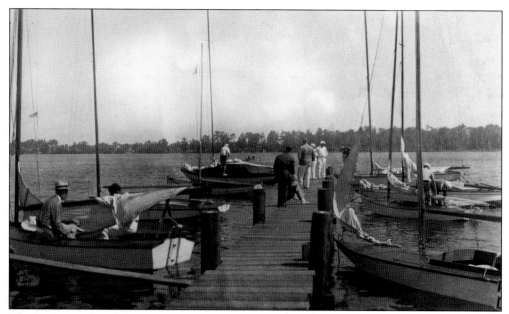

The Pontiac Yacht Club was started in 1934. A group of members from the Oakland County Boat Club on Sylvan Lake wanted a quieter club focused on sailing. Its first commodore was Shirley Bomhardt. There were 14 boats that first year. This is an early photograph of the club's docks on Cass Lake. (Courtesy of Joan Green.)

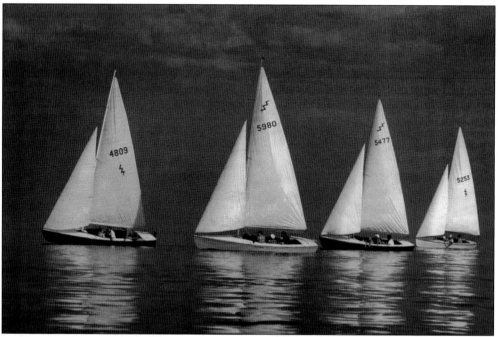

The Lightning sailboat model dates to the 1930s. It became very popular due to its speed, responsiveness, and construction. In 1942, six members of the Pontiac Yacht Club took delivery of new boats. A Lightning is sailed by a skipper and two crew. It measures 19 feet in length, six feet and six inches at the beam, with 177 square feet of sail plus 300 square feet of spinnaker. (Courtesy of Joan Green.)

This sandstone grill was built in 1949 at the Pontiac Yacht Club in Orchard Lake. The materials for it were donated by Bill Meagher, Harold Dudley, and Merle Voss. It was a two-burner with an overhead light. Shown in front are, from left to right, Yvonne Cousins, Kathryn Gray, Mrs. Dean Thompson, and Ila Phips. (Courtesy of Joan Green.)

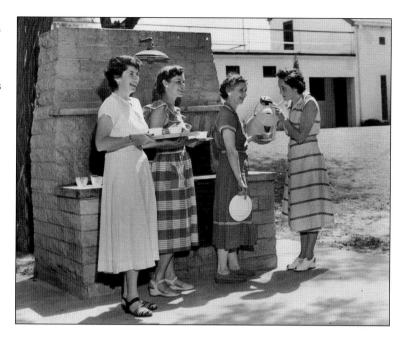

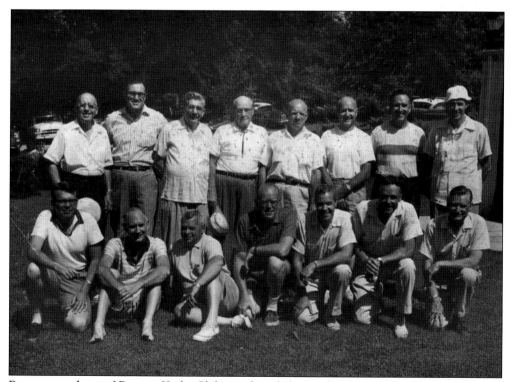

Past commodores of Pontiac Yacht Club are, from left to right, (first row) Charles Buck, Sam Dibble, Al Oberson, Ken Raymond, Don Neal, Gene MacCracken, and 1958 commodore Jim VanDoren; (second row) Roy Connolly, Harold Cousins, George Wasserberger, Ray Ransom, Van Phipps, Al Gray, Les Huntwork, and Alex Clark. (Courtesy of Joan Green.)

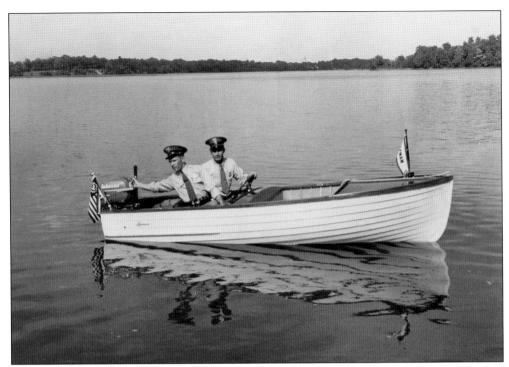

The Orchard Lake Village police force was established in 1928. Clarence Carson was its first chief. This is the first police boat from the 1950s. Officer "Red" Morgan is behind the wheel, and patrolman Ed Heiron Jr. is next to him. Apple Island is to the right. Morgan also served on the West Bloomfield (later Tri-City) Fire Department. (Courtesy of GWBHS.)

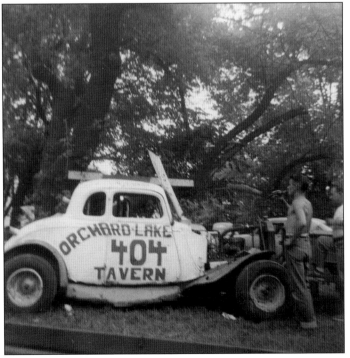

It is not certain where the racetrack was, or the Orchard Lake Tavern, but this race car was driven by Pine Lake Inn proprietor Bill Periard. He was injured in one race, necessitating an ambulance trip to the hospital. The ambulance on standby at those races was provided by Godhardt Tomlinson Funeral Home, which used the hearse as an ambulance for a time to earn extra income. (Courtesy of Mark Periard.)

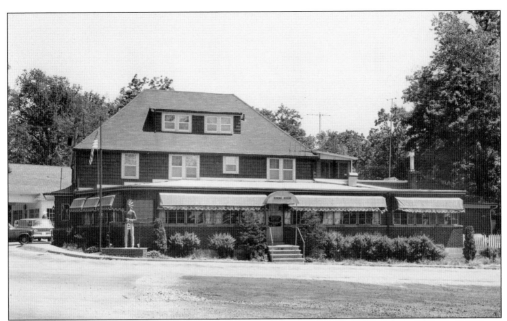

The little Wilkins store evolved into a major landmark in the area, Wilkins Restaurant. Fred Wilkins was a graduate of Michigan Military Academy. He and his wife, Bertha, lived on Indian Trail, right off of Orchard Lake Road, within walking distance of the restaurant. Their restaurant closed, changing owners around 1970, and it later closed permanently. Sadly, in 2014, the building that housed Wilkins Restaurant was razed to make room for a drugstore. (Courtesy of GWBHS.)

Laborers from St. Mary's Preparatory School are seen here in 1956. The newly constructed Orchard Lake Post Office is getting some landscape tending. Perhaps the new drop-off mailbox is about to be installed, as it was located for years where these young men are working. The post office closed decades later. There have been several post offices throughout the area over the years. (Author's collection.)

West Bloomfield High School

Class of 1957

West Bloomfield High School opened in January 1955 in Orchard Lake. Its football field was in Keego Harbor. This 1957 class was the third to graduate from the new school. The portrait of the first class, in 1955, was misplaced, and it still has not turned up. That first class has since been named the "lost class of '55." The students of that class were moved midyear into the new school from Roosevelt School. (Courtesy of GWBHS.)

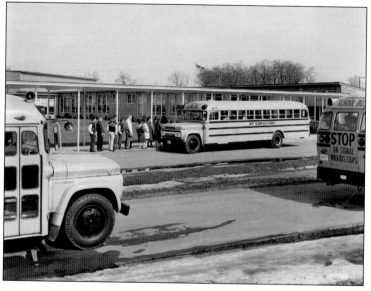

Roosevelt School was technically West Bloomfield's first high school, as all students from the district attended there. Roosevelt taught all grades, K–12, and therefore did not have the facilities other high schools offered. This precipitated the need to build the new school on Commerce and Orchard Lake Roads. It is now Abbot Middle School. (Courtesy of GWBHS.)

Four

City of Sylvan Lake

By almost any definition, Sylvan Lake is tiny. But, it has an outsized history and claims to be the "Prettiest Little City in the State of Michigan." Consisting of only 1.5 square miles, it has just 1,720 residents as of the 2010 census. It certainly captured the fancy of its first settler. Its history dates to 1818, when an expedition led by Rev. John Montieth rode into the area to see what lay between Detroit and the newly established post of Pontiac. The lake, which lay closest to Pontiac, was surrounded by a fringe of tamaracks and was considered by the explorers to be the most beautiful. They named this body of water Timber Lake. It was later changed to Sylvan Lake.

In 1824, Isaac Voorheis purchased land on the eastern side of the lake. Eventually, his family, for whom a road is named in the area, owned a vast piece of property.

A summer hotel called Sylvan Lake Inn was begun in 1893 by Merrill B. Mills. The resort was destroyed by fire in October 1903. Around 1906, Mills donated this property to the *Detroit Free Press* for use as the Fresh Air Camp for underprivileged children. The camp operated for 55 years. The newspaper deeded the property to the City of Sylvan Lake in 1962, which later developed some of the old buildings into the Community Center. By 1921, the community had grown sufficiently to be incorporated as a village. Whitfield School was completed in 1927, replacing the two-room schoolhouse that had stood on the same site and succeeded the first one-room school established in 1852. Sylvan Lake City Hall was built in 1929, designed by architect Charles Fisher, a city resident, and his engineer brother William Fisher of Pontiac.

In February 1947, the village became the city of Sylvan Lake. In the same year, Sylvan residents voted to become part of the Pontiac School District. Court-ordered busing in the early 1970s for the Pontiac School District caused many families with young children to sell their homes. Sylvan's population dropped after 1970, but it has been slowly climbing since.

Fireworks have been a tradition in Sylvan Lake for as long as anyone can remember. They are currently sponsored by the Oakland County Boat Club, which has been part of Sylvan Lake history since 1912.

Merrill Mills had a dream to create a resort hotel and community on Sylvan Lake. He began planning the Sylvan Lake Inn's construction, complete with streetcar service from Pontiac, in 1893 with three partners. After only a few short years, the inn lay in ashes and the community took on a life of its own, transitioning from a cottage community to one with many year-round homes. (Courtesy of GWBHS.)

Merrill Mills published a booklet promoting the virtues of his new inn and the lake community around it. Horseback riding, golfing, swimming, and boating were some of the many recreational activities offered. This is the cover from that booklet, meant to encourage city dwellers to spend their weekend and summer months at the lake. (Courtesy of GWBHS.)

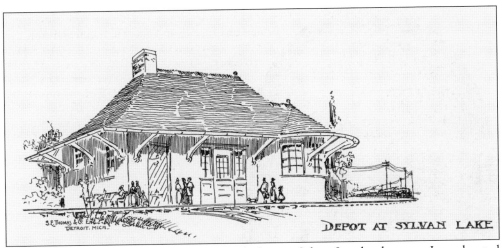

The railroad depot in Sylvan Village came with the new Sylvan Inn development. It was located near the current city hall, on the track serviced by the Michigan Air Line, a subsidiary of Grand Trunk Railroad of Canada—or was it? Not much is known about the station, or if it was ever built. This, the only known image of the station, was part of the Sylvan Lake Inn booklet promoting the new resort's conveniences. (Courtesy of GWBHS.)

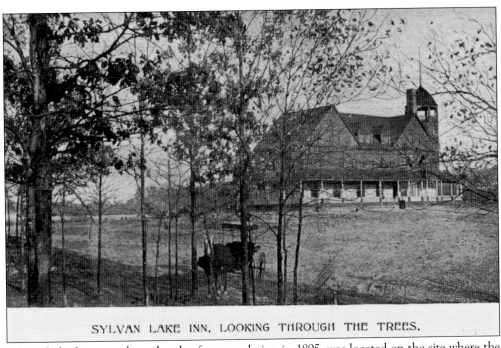

Sylvan Lake Inn, seen here shortly after completion in 1895, was located on the site where the Community Center now stands. The streetcar, later the Detroit United Railway, came from Pontiac via Telegraph Road onto Garland Street, with a stop at Pontiac Drive, where riders could hire a jitney to take them the rest of the way to the inn. The electric streetcar proceeded to Keego Harbor, Orchard Lake, and Farmington before returning to Detroit. (Courtesy of GWBHS.)

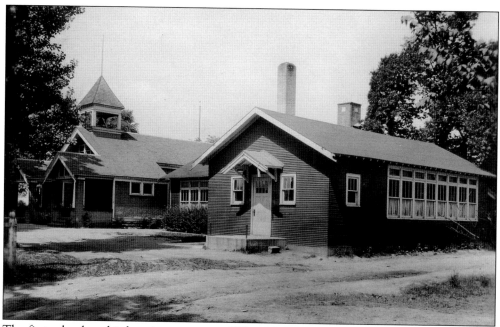

The first school at this location was part of West Bloomfield Township, before Sylvan Village existed. It was a fractional school district then. Some people have called this second school, built in 1894, Skae or Hammond School. In 1927, the name Daniel Whitfield graced the third school's facade until its demolition. The land the school was built on was donated by the Whitfield family. (Courtesy of David Walls.)

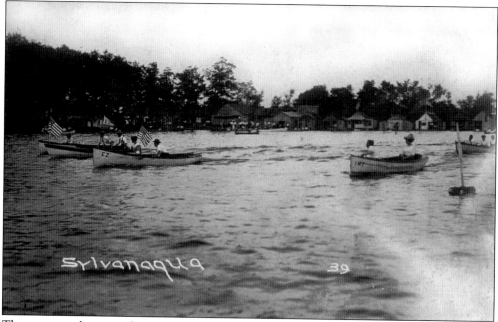

There was no shortage of activities on the lakes during summer months. The Sylvanaqua is an example of such early activities as Sylvan Lake's summer community flourished. Whether this was the beginning of the hydroplane races decades later is unknown. Sailboat races took precedence during World War II due to gasoline rationing. (Courtesy of Helen Jane Peters.)

Tower Beach, seen here on August 18, 1918, was a product of the Pontiac and Sylvan Railways. The electric streetcar, established initially for the Sylvan Lake Inn, came into the village off of Telegraph Road, bringing summer visitors from near and far. The tower allowed swimmers to climb high and slide into the lake on a board. Swimmers could also rent a swimsuit for the day at this beach, which flourished in the early 1900s as a tourist area on the east shore of Sylvan Lake. (Courtesy of Helen Jane Peters.)

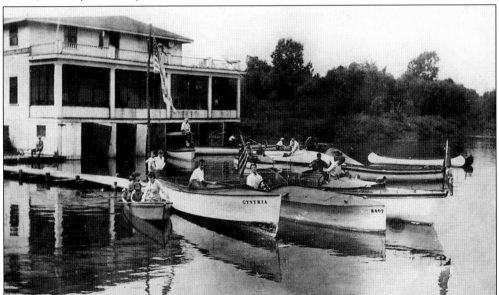

The Oakland Boat Club, erected in 1917, was built over the water so that boats could park beneath it. This was a common technique; dance halls of the day were built out beyond shorelines. In 1930, though, the boat club embarked on moving the building entirely onto dry land. This photograph, likely from the 1920s, shows a variety of boat styles used on the lake at the time. During World War II, powerboats were restricted in order to save on gasoline. As a result, sailboats became more popular. (Courtesy of Kennedy and Charlotte Gamble.)

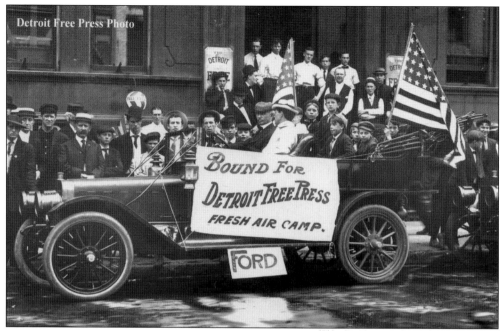

The Fresh Air Camp vehicle, a Ford, heads to Sylvan Lake for two weeks of summer camp. The camp was created from a donation by the Merrill Mills family to the *Detroit Free Press* in 1906. Funds to construct camp buildings were raised by many means, including Detroit schoolchildren collecting pennies. (Courtesy of *Detroit Free Press*.)

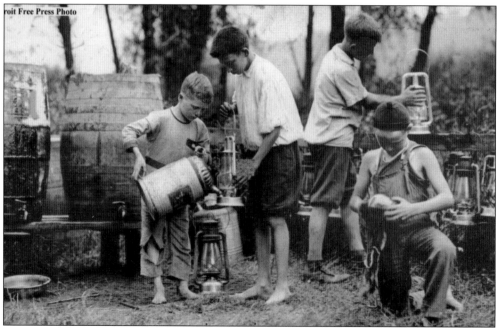

The goal of the Fresh Air Camp was to give underprivileged children from the city a break from impoverished urban life and the heat of the city in summer. This early *Free Press* photograph shows boys cleaning and filling the oil lamps. The change of lifestyle offered fresh air, fun, and good food. (Courtesy of *Detroit Free Press*.)

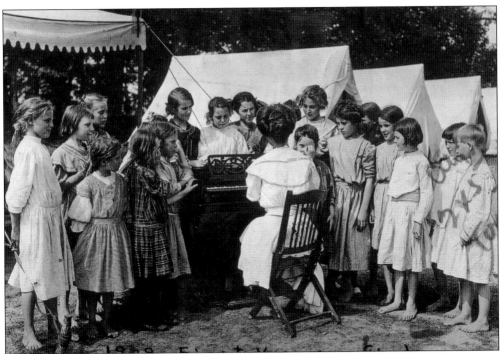

This early *Free Press* photograph shows just how primitive things were at this time. The organ has been set up outdoors, providing kids the opportunity to sing and learn songs. The camp was originally conceived as a service for boys only. This 1909 photograph was taken in the first year that girls were allowed. Note the tents in the background; early on, there were no permanent structures at the camp. (Courtesy of *Detroit Free Press*.)

Some boys may have never had the chance to play or learn baseball. These Fresh Air Kids likely did not have the means to buy mitts, bats, and balls. Big cities in the early part of the 20th century were confined, hot, and grimy places in the summer, especially in the low-rent districts. Though many young children were undoubtedly homesick during these camps, most created great memories to last a lifetime. (Courtesy of *Detroit Free Press*.)

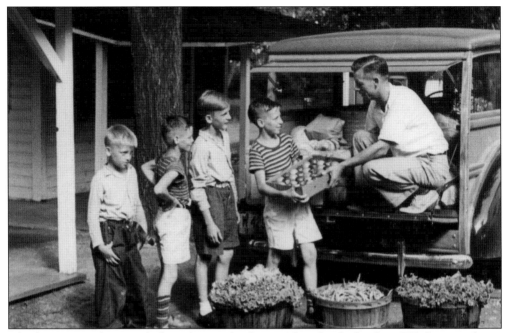

This later camp photograph shows boys unloading produce for the kitchen. While some chores were part of their stay, kids were at camp to be kids. Many of the children living in Sylvan Village interacted with camp kids. (Courtesy of *Detroit Free Press*.)

This camp kitchen worker must have had lots of help to keep scores of hungry and active children fed three times a day. The food was fresh, nutritious, and tasty. Before the Kahns donated funds for a dining hall, tents were used for preparing meals and feeding the kids. (Courtesy of *Detroit Free Press*.)

Every morning and every evening, the flag was raised and lowered. The kids gathered around and recited the Pledge of Allegiance. This photograph shows kids from one of the last years of the camp. In 1962, the Fresh Air Camp closed, and the *Detroit Free Press* donated the land to the City of Sylvan Lake. (Courtesy of *Detroit Free Press*.)

When the camp first started, the only structures were tents. Donations from individuals and groups facilitated the building of structures for camp use. In the 1920s, the Countryside Improvement Association set a goal of raising funds to build a dining hall. Mrs. Albert Kahn was a great supporter of the camp and a member of Countryside. She got her husband to design the new hall. The Kahns had a summer home on Walnut Lake in West Bloomfield on 86 acres. (Courtesy of *Detroit Free Press*.)

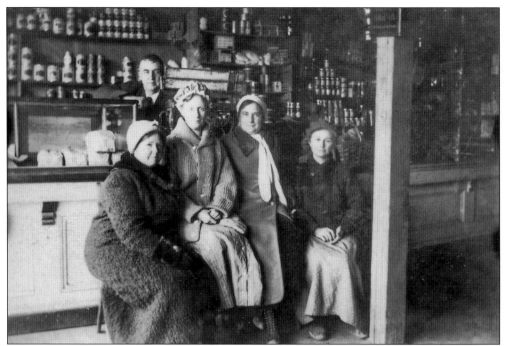

Steve's Store was on Garland Street and Telegraph Road, right on the water. It was a market, boat rental, and barbershop. There were apartments above the store. It was razed in 1955, just prior to the widening of Telegraph Road, which was completed in 1957. Steve's Store, also called the General Store, was owned at different times by the Vitasinski and Mazza families. (Courtesy of Linda Zielinski.)

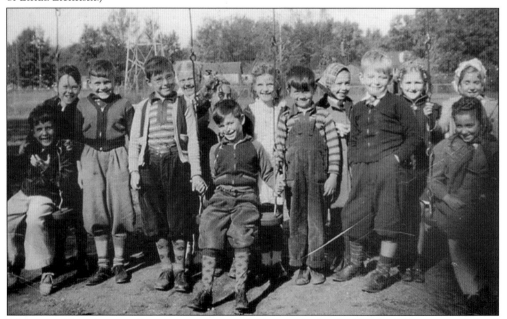

The year of this photograph is not certain. It was taken in the first half of the 20th century behind Daniel Whitfield School. Playgrounds at one time had many kinds of equipment, and recess was held three times a day. (Courtesy of Sharie Husted VanGilder.)

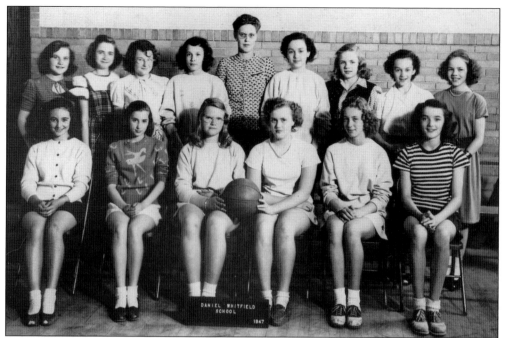

This is the 1947 Daniel Whitfield girls' basketball team. Pictured here are, from left to right, (first row) Madah Jo Mack, Marjorie Shirey, Marian Lingle, Sally Shaffer, Marcia Winges, and Patty Manning; (second row) Joanne Beedle, Carolyn Dickie, Sally Pulver, Marilyn Kistner, Martha Winges (coach), Sue Stolpe, Sharie Husted, Charlotte Ward, and Evelyn Bochnig. (Courtesy of Joe Leavy.)

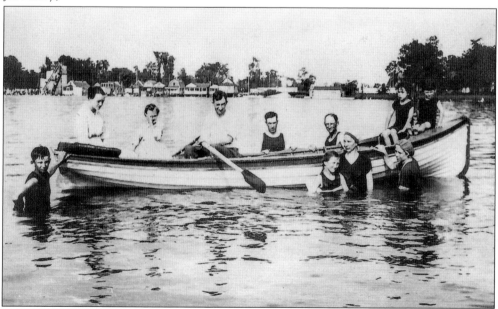

The Callahan family is shown in Sylvan Lake near Tower Beach in 1917. Sylvan Lake is part of the Clinton River Watershed; the river essentially passes through the lake. Water levels are regulated in two locations: at Cass Lake Road between Cass and Otter Lakes and at the Dawson Mill Pond dam. (Courtesy of Hank and Esther Callahan.)

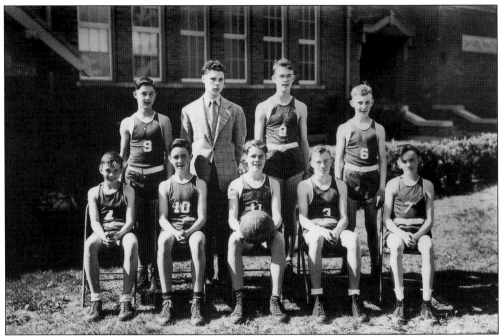

The Daniel Whitfield boys' basketball champs for 1946 pose for a photograph. Pictured are, from left to right, (first row) Allan Stone, Jim McLane, Jerry Webster, Chuck Wixom, and Burt Crawford; (second row) Paul Bochnig, Richie Leitner, Chuck Koella, and Ron Manning. This photograph was hanging in the school just prior to its demolition. (Courtesy of Sharie Husted VanGilder.)

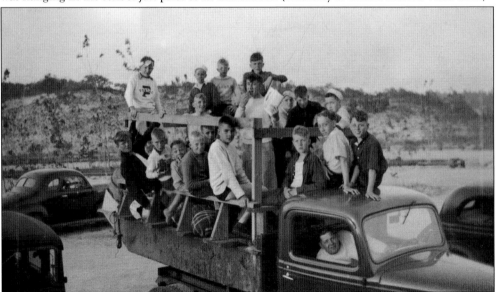

In 1939, the Boy Scout troop from Whitfield School had an outing that would last from Tuesday through Friday one week that summer. The troop traveled to Sleeping Bear Dunes and back. Some of the boys in the truck include Bob Green, Bill Webster, Bill Graff, Jerry Stoll, Lyle Filkens, and Marvin Hole. The driver is Bob's dad, Clark Green Sr. The truck was owned by Sylvan Village. Benches were installed in the back to carry the whole troop. In addition, a canvas cover could be used to provide protection in the back. (Courtesy of Sharie Husted VanGilder.)

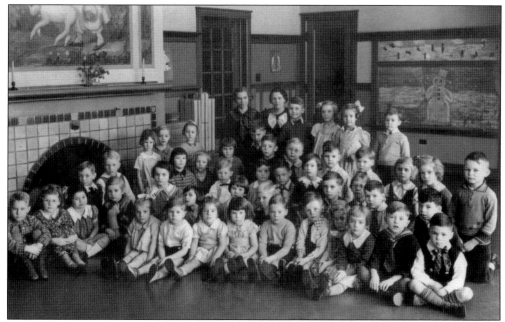

When Daniel Whitfield School was rebuilt in 1927, the kindergarten classroom was at the center front of the building. It had a fireplace, two entry doors directly to the outside, a painting of "Mary Had A Little Lamb" by Roy Gamble, and Pewabic tile around the hearth. Later, the kindergarten moved, eventually into an annex housing kindergarten through second-grade classrooms. The original room became a sixth-grade class. (Courtesy of Sharie Husted VanGilder.)

Starting in the 1920s, Dickie Lumber & Coal Co. was a staple of commerce for Sylvan Lake and adjoining communities. Originally selling coal and lumber, it later dealt in lumber and trim. It was located on Orchard Lake Road and had a railroad spur behind it to accommodate flatbeds of incoming lumber. It was consolidated with Poole Lumber in the late 1970s and eventually sold off. The site became a strip mall. (Courtesy of Hugh Dickie.)

Young Frank Dickie, whose father ran Dickie Lumber and Coal, will not be getting any milk from this cow. The photograph was taken behind Daniel Whitfield School in the 1930s. Frank is a descendant of David Dickie, who had huge orchards in West Bloomfield in the late 1800s. The school had annual fairs, including science fairs, which might explain this milking demonstration. (Courtesy of Hugh Dickie.)

Second-generation lumberman Frank Dickie is shown here in 1964 behind the counter of the business his father started. Butch Blaylock also worked there for many years. Eventually, third-generation family member Hugh Dickie began working part-time at the age of 12; however, he would not get the chance to carry on the business when he reached adulthood. Mention should also be made of John Murphy and his son John, who worked at the lumberyard. (Courtesy of Hugh Dickie.)

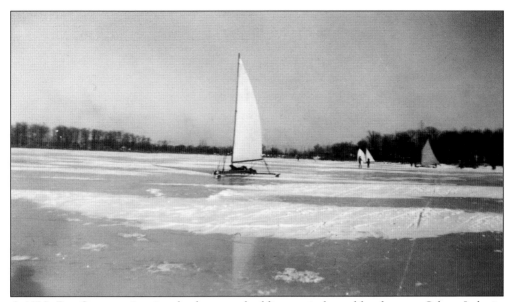

A 1930s Boy Scout project involved a troop building an iceboat, like these on Sylvan Lake in the 1940s. The lakes in and around Sylvan Lake do not offer only summertime attractions. Iceboating, ice-skating, and hockey are wintertime ways of having fun and getting exercise. (Courtesy of Jan Morrill.)

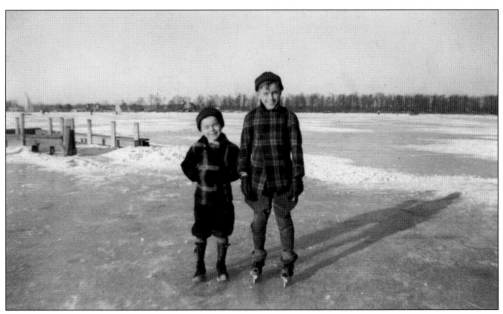

Brothers Leon (left) and Rod Morrill skate near the Oakland County Boat Club in the 1940s. In those days, one could get skates sharpened at the local hardware store. A child could buy a pair of used skates if the piggy bank was low, or he or she could trade old skates for new ones if the piggy bank was full. (Courtesy of Jan Morrill.)

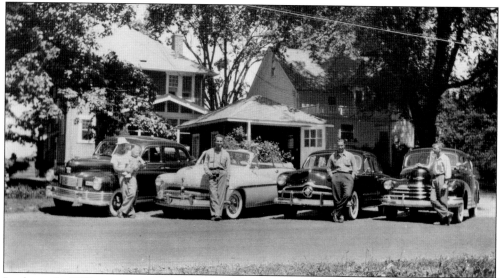

In the early 1950s, veterans were spending money on new cars, houses, and college education through the GI Bill. It took several years after the war ended for car companies to come out with completely new models because the firms had been consumed with making military vehicles and hardware. It was not until the late 1940s that new models began to appear, such as the 1949 Ford (second from right) and the later Mercury (second from left). (Courtesy of Chet Hall.)

During World War II, the need for iron was endless. Salvaging and scrapping metal from unneeded items of all kinds was of the highest priority. Here, Dale Morrill poses at Memorial Park in Sylvan Village at one such scrap-metal drive during the war. The names of servicemen from the community are listed on the sign. (Courtesy of Jan Morrill.)

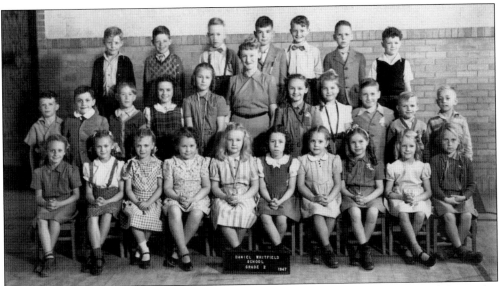

This is the second-grade class at Daniel Whitfield School in 1947. Shown are, from left to right, (first row) Maureen Foster, Joanne Wharram, Patricia McLeod, Jane Skelley, Judith Lauckner, Barbara Lecornu, Lavon Lowe, Helen Jane Spark, Mary Sue Dahlgren, and Manitta Foster; (second row) unidentified, Billy Walkerdine, Wayne Morey, Sharon McRae, Karen Beam, Nan Stolpe, Barbara Monteith, Kathleen Rouse, David Stott, Donald Kline, and Alvin Schultz; (third row) Frankie Seed, unidentified, Dennis Tryon, Joe Sawyer, Roy Durfee, Billy Barrow, and Teddy Collom. (Courtesy of Helen Jane Peters.)

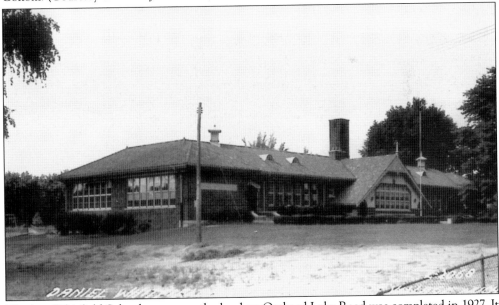

The last Whitfield School to occupy the land on Orchard Lake Road was completed in 1927. It was designed by architect Charles Fisher of Pontiac and his engineer brother William Fisher. It changed a lot over its lifetime. An auditorium/gymnasium was added early on, with a cafeteria below it. A two-story classroom addition was also added later. Finally, in 1955, an annex for levels kindergarten through second grade was added to the west. The school was annexed into the Pontiac School District in 1947. (Courtesy of Helen Jane Peters.)

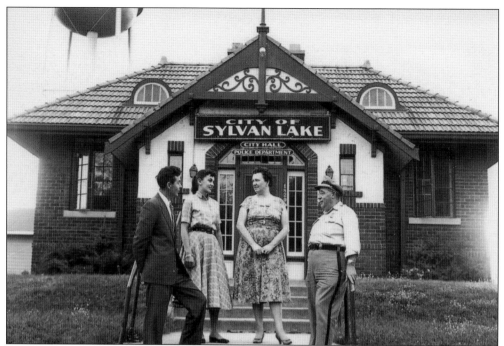

Sylvan Lake City Hall was built in 1929, two years after Sylvan became an incorporated village. It was designed by Pontiac architect Charles Fisher and his engineer brother William Fisher. They were responsible for designing Whitfield School in 1927. Pictured here on October 1, 1957, are, from left to right, Louis G. Barry, city manager; Virginia Flath, assistant clerk; Marjorie Wilson, clerk and treasurer; George Purdy, chief of police. (Courtesy of Roxane Pfeffer Grandstaff.)

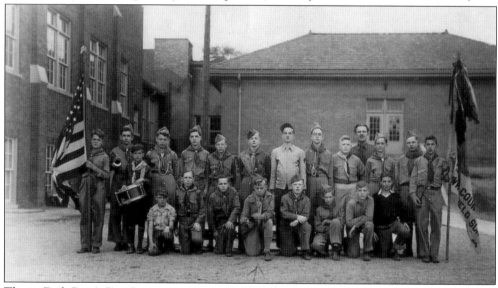

This is Dick Prue's Boy Scout troop in 1945. The photograph was taken at the rear of Daniel Whitfield School. Every Memorial Day, the Cub Scouts, Boy Scouts, Girl Scouts, and Brownies took part in the parade that culminated at Memorial Park on Garland Street, where a wreath was laid in honor of the residents who had fought and died in service to their country. (Courtesy of Joan Prue.)

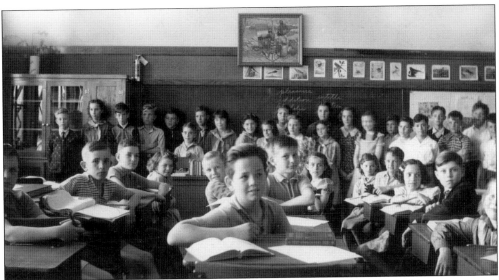

The classrooms at Whitfield Elementary School covered several periods, as the building experienced several additions. In this 1930s photograph, the kids are in the main building, which had brown linoleum flooring, radiator heat, slate blackboards, and no air-conditioning. Pictures of bird species are visible on the front wall, as is a painting of a Native American weaving. (Courtesy of Bob Green.)

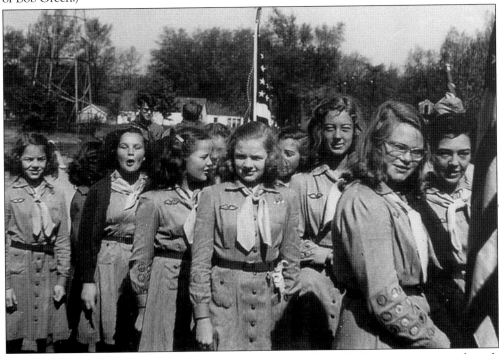

One of the Girl Scout groups from Whitfield had each girl's mother host a meeting and teach the girls something of their choice. One girl's mother chose sewing on buttons as an important lesson to share. Though it might have seemed like an extremely simple task to teach young girls, sewing buttons actually involves several important details. These Whitfield Girl Scouts are seen in the 1940s. (Courtesy of Sharie Husted VanGilder.)

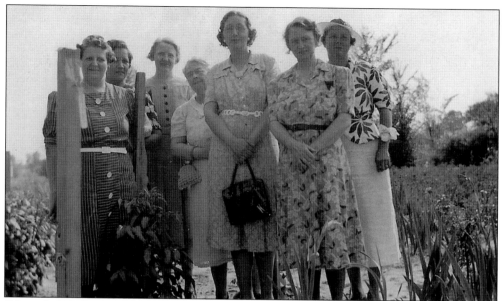

Sylvan Lake's first garden club was begun in 1939. Members pictured here are, from left to right, Mrs. Merle Mitchell, Mrs. Lester Snyder, Mrs. Claude Kimler, Mrs. W. H. Sutton, Mrs. William Walkerdine, Mrs. Stanley Filkins, and Mrs. Guy Tubbs. (Courtesy of Sylvan Lake Garden Club.)

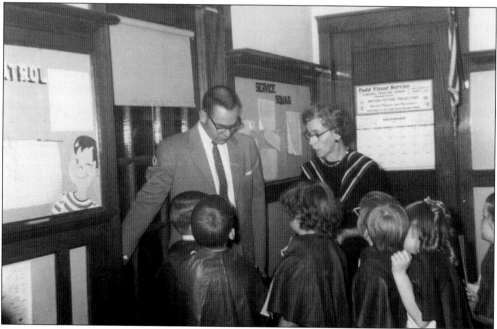

Helen Jane Spark is pictured here with kids preparing for a play. One of Whitfield's most beloved teachers, she graduated from Michigan Normal College (now Eastern Michigan University) and started teaching in a one-room schoolhouse in Michigan's thumb area in 1925. She began teaching at Daniel Whitfield in 1947, retiring 20 years later. She taught first, second, and fourth grades there. She lived in Sylvan Lake and walked to and from school each day. (Courtesy of Mrs. Spark's student, Jeff.)

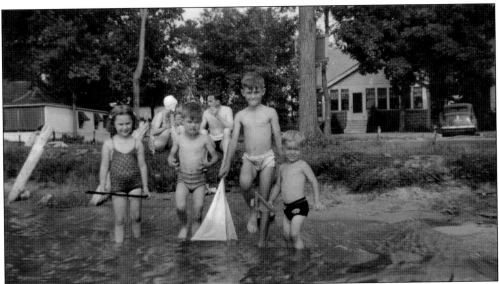

Over the years, Sylvan has had two beaches, an old beach and a new beach. The beach on Lakeview Avenue was considered the old one, despite that fact that Tower Beach on Ferndale dates to the 1920s. The beach on Lakeview Avenue was narrow between the road and the lake. It was only after canals on Ferndale between the lake and the road were filled, enlarging the park area fourfold, that it became the main beach for the community. Pictured at the old beach in the 1940s are, from left to right, Barbara Holloway and Dale, Rod, and Leon Morrill. (Courtesy of Jan Morrill.)

Ferndale Beach, the new beach, had this swimming raft to swim out to and dive off of or to lie out on and sun with friends. The new beach, seen here in the 1940s, was a major increase of park and beach area over the old beach. It had horseshoe pits, swings, grills, and lots of green space. It is still used today, as the old beach does not have beach space, only docking. (Courtesy of Jan Morrill.)

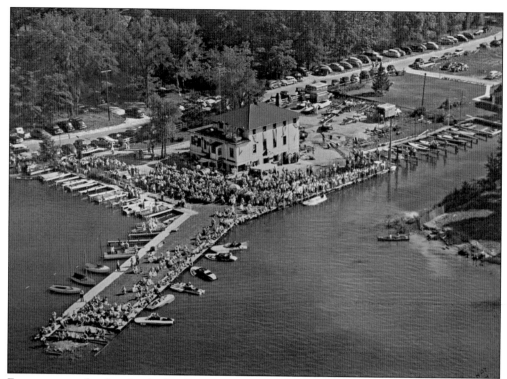

Every summer for decades, hydroplane races were held on Sylvan Lake as shown in this aerial photograph from 1949. Oakland County Boat Club hosted the event, in which all boats were brought and dropped into the water with cranes. The whine of the diminutive racers could be heard from a mile or more away. That sound, heard every summer, meant that the races were taking place. The event is still held, but on another lake. (Courtesy of Anna Lee Kennedy.)

Roger Reuter (pictured) was the second generation of his family to work at Sylvan Market, shown here around 1970. His father, Lawrence, opened the store around 1950. Don Larson and Tommy Stammen were stock boys in the 1970s. Every fall, hunters would bring their deer to be butchered in the garage bay on the side of the market. Next door to the market was a little diner that had many tenants over the years, most famously Dallas's Iron Kettle, known for all the working tradesmen of the day stopping for breakfast and lunch. (Courtesy of Don Larson.)

Five

CITY OF KEEGO HARBOR

It was Joseph Sawyer's vision of creating a workingman's Miami Beach that gave birth to Keego Harbor. In 1900, he published a book, *Keep Your Eye on Keego Harbor*. The book was used to entice prospective buyers to settle on the land surrounded by Cass, Pine, Orchard, Dollar, Elizabeth, Sylvan, and Hammond Lakes.

Sawyer's first endeavor was the building of a canal from Cass Lake to Dollar Lake, thereby turning the smaller lake into a harbor. He named the new community Keego Harbor after the slender Keego fish.

James Strong is considered the first settler, having arrived in what is now Keego Harbor in 1864. His son Lloyd built Strong's Pavilion in 1911. The first school was built in 1914, and the fire department was organized in 1926.

The community's leaders gathered in the spring of 1954 as a charter commission to formulate plans for Keego Harbor to become a city. On February 22, 1955, the charter was forwarded to Lansing, where it was approved by Gov. G. Mennen Williams on March 25. At a special election on April 20, 1955, the people voted to become a city.

The old school on the corner of Pridham and Orchard Lake Roads was used as the first city hall. The second one was housed in a building owned by Frank Marriott at Orchard Lake Road and Pine Lake Avenue. In the late 1950s, the city purchased land on Beechmont Street for a new city hall. The building was dedicated in October 1966.

In the first year after it became a city, the city council voted that any money remaining at the end of the fiscal year was to be put in escrow toward the building of a sewer and water system. When the county introduced the extension of the Farmington Interceptor to West Bloomfield, Keego Harbor was the only city in the area that could afford to take advantage of the offer. A grant from the federal Department of Housing and Urban Development made the water system possible in 1967.

Keego Harbor's population in 2012 was 3,003, up 8.5 percent from the 2000 census. The city's students attend West Bloomfield schools.

Joseph E. Sawyer is recognized as Keego Harbor's founding father. A lawyer from Pontiac, he sought refuge and tranquility from city life. The Detroit United Railway was already running through the area when he platted the first subdivision in 1912. He is responsible for naming the town "Keego," after a Native American word for fish, and "Harbor," for the harbor he created by connecting tiny Dollar Lake to Cass Lake by canal. (Courtesy of Coral Lou Walling.)

Joseph Sawyer (in background) was serious about his dream of Keego Harbor being a new kind of community. He brought his family with him (Mrs. Sawyer is in the right foreground) from Pontiac to show all newcomers that he was in it for the long haul. His poem "Out at Keego Harbor," which he wrote early on, was put to music by Clifford Stock. It became the official song of the city in 1998. (Courtesy of Coral Lou Walling.)

This early Keego Harbor map shows the first streets and lots. It would later expand to Maddy Lane to the east. Joseph Sawyer did not believe in too many government regulations, although he did have some guidelines for building homes and development. As a result, the community never incorporated as a village, instead jumping right to cityhood, although it took until 1955. (Courtesy of Coral Lou Walling.)

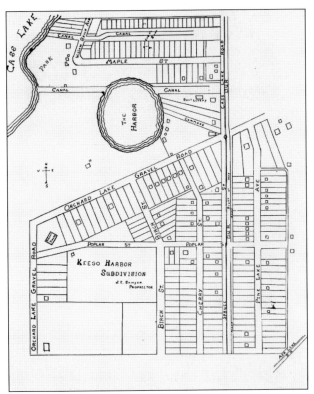

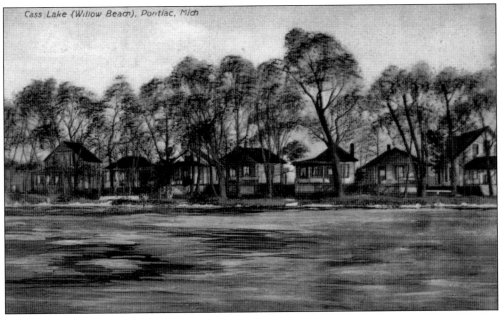

This is Willow Beach Avenue, seen from the lake in the early 1900s. At this time, Keego Harbor consisted of only cottages; there were only a few year-round homes. Some longtime residents can confirm rumors of the Purple Gang residing on Cass Lake Avenue in one large house during Prohibition and beyond. The gang was reportedly shut down for running a prostitution business. (Courtesy of Joan Walsh.)

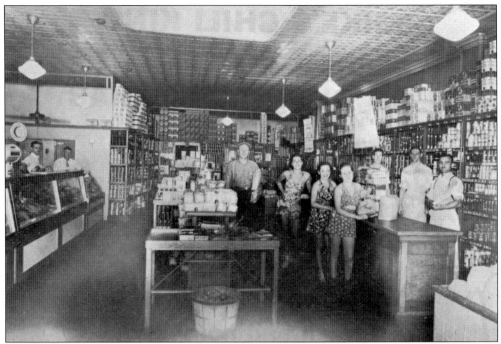

A&P has been around since the Civil War, though it no longer has stores in Michigan. This early store was at the northeast corner of Cass Lake and Orchard Lake Roads in downtown Keego Harbor. A&P later built a store at the bend next to Ward's Point in the 1960s. At that time, A&P was the largest retailer of any kind in the country. (Courtesy of Coral Lou Walling.)

The Keego Cass Women's Club was responsible for starting the library for West Bloomfield Township. This small clubhouse was one early location for the library, which was later housed in the old Keego Harbor School. In 1961, the library moved out of Keego and into its new building on Orchard Lake Road, across from the current high school. It eventually moved to its present location on the township campus of buildings. (Courtesy of GWBHS.)

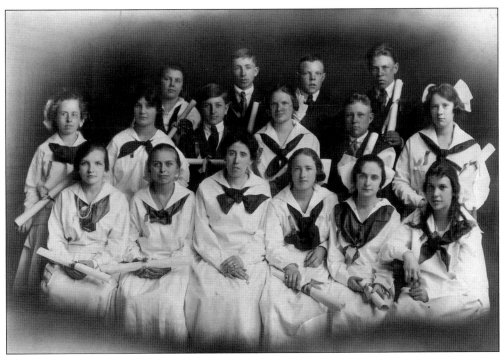

This photograph was taken the year Roosevelt School opened. It replaced the earlier Keego Harbor School, from which these ladies graduated in 1920. The old school went on to be used for several more decades before falling into obsolescence. At the time of this photograph, Keego Harbor was a fledgling cottage community. But it was about to begin adding more substantial businesses. (Courtesy of Coral Lou Walling.)

Keego Harbor School was the first school built in the small town, in 1914. It also served as the first city hall after Roosevelt School opened. An early township library was also located there for a short time before the first official township library was built in 1961 on Orchard Lake Road, across from the present-day high school. (Courtesy of Coral Lou Walling.)

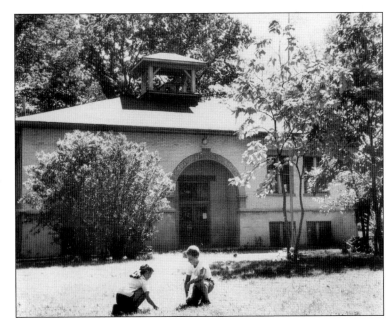

This is the 1930 Roosevelt School football team. Roosevelt was the high school of the area for most nearby West Bloomfield residents and would remain so until 1955, when the new high school opened. The football field from early on was by the railroad tracks at the foot of Summers Street. The school is named for Theodore Roosevelt. (Courtesy of Coral Lou Walling.)

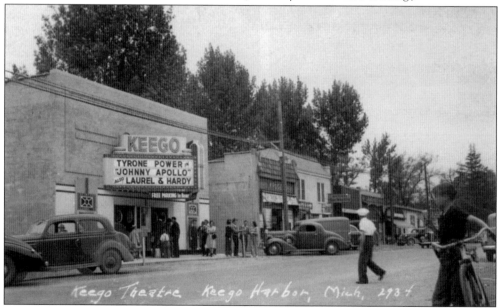

The Keego Theater, shown here in 1934, was the only theater close to Sylvan, Sylvan Manor, and other neighborhoods within walking distance. In its last years, it was sold to someone who wanted to show X-rated movies. The community rose up and picketed until the new owner relented. The theater showed family films until it was torn down to make way for a Rite Aid. (Courtesy of Coral Lou Walling.)

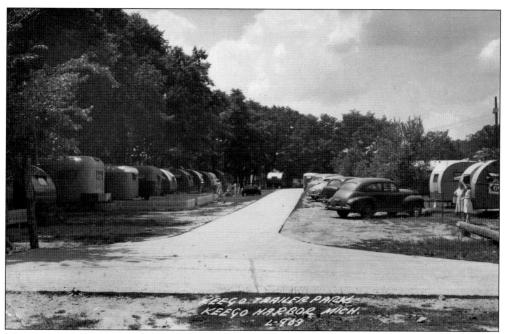

The Keego Trailer Court is shown here in the 1940s. The occupants of these trailers were likely a combination of summer visitors and people moving with their jobs. Postwar America saw many large infrastructure projects taking place. Many veterans lived on the road in trailers such as these with families, moving from project to project. Keego still has a trailer court on the boundary with the city of Orchard Lake Village. (Courtesy of GWBHS.)

This soda fountain was at Covey's Drugstore, on the corner of Fordham Street and Orchard Lake Road. It is seen here in the 1950s. Between Keego Hardware and Covey's was Vincent's, a well-known restaurant in the area that had several owners over time—and great cinnamon rolls. In the early 1960s, a fire broke out at the restaurant after operating hours, and both buildings next to the hardware were lost. It was the second major fire in this location in 20 years. Both times, the hardware store survived essentially unscathed. (Courtesy of Coral Lou Walling.)

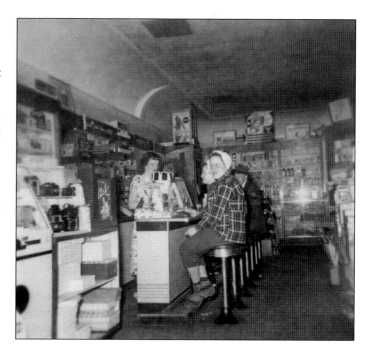

Duncan McGregor Ward was the first pastor of Trinity Methodist Church. When he came to Keego Harbor, there was no church. Methodists were prepared to build one, but in the meantime services were conducted from the pastor's home. Other denominations continued to meet at the old Keego Harbor School. When the Orchard Lake Community Church became Presbyterian, many Keego residents went there. In the 1950s, a Baptist church was built on Cass Lake Road. (Courtesy of Coral Lou Walling.)

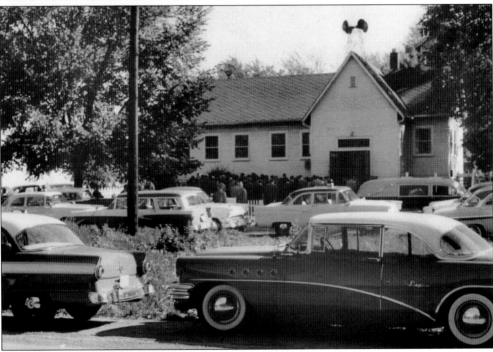

Trinity Methodist Church was the first church built in Keego Harbor, its cornerstone laid on September 4, 1927. The summer residents were of various faiths, mostly protestant Christian. A meeting was held on what type of church to build and for what congregation. The Methodists split off and built their own chapel following that meeting. Our Lady of Refuge Catholic Church was erected in 1941; parishioners had been attending Mass at the Polish seminary since 1909. This photograph was taken in October 1956 during the funeral of Keego Harbor police chief Calvin Baxter. (Courtesy of GWBHS.)

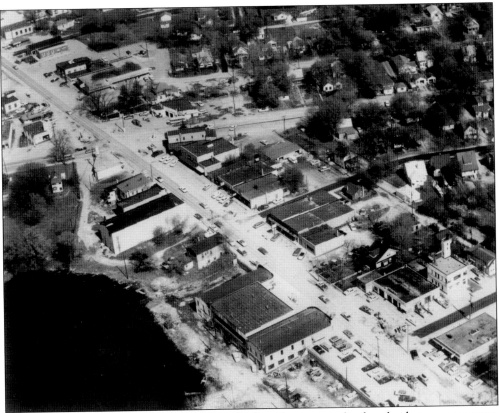

This aerial photograph of downtown Keego Harbor shows many landmarks that are now gone. The future Backseat Saloon (the old icehouse) is the small building on the shores of Dollar Lake. Just above it is the Keego Theater. Note that the parking on the street is pull-in, and the road has two lanes. The top story is gone from Keego Hardware. This photograph was taken from a hot-air balloon shortly after the fire that killed police chief Calvin Baxter. Other establishments included Groners five-and-dime store, a barbershop, and a lot more. (Courtesy of Coral Lou Walling.)

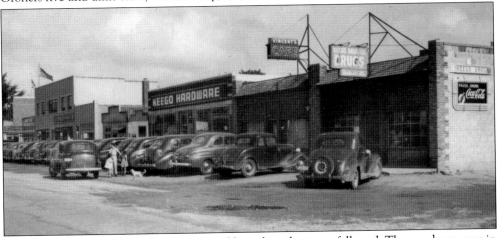

After Keego Hardware No. 1 opened, several branch outlets soon followed. The warehouse was in downtown Pontiac in the old Standard Vehicle factory. The stores were split off in 1953; the Keego location was the only one to keep the Keego Hardware name. (Courtesy of Coral Lou Walling.)

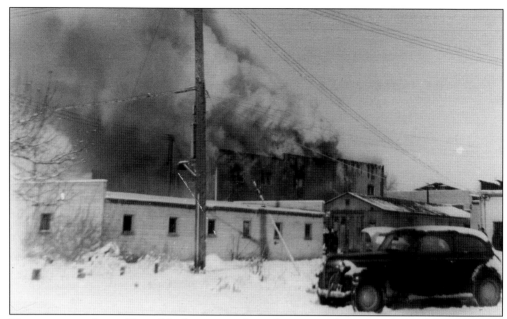

There were two fires at Keego Hardware, one above the store and one next door. This one in 1944 broke out above the store, causing it to close temporarily. The owner's daughter recalls all the merchandise being moved to the basement of the nearby Community National Bank until the building was repaired. The upper story was not rebuilt. This view shows the rear of the building, a short distance from the fire department. (Courtesy of Coral Lou Walling.)

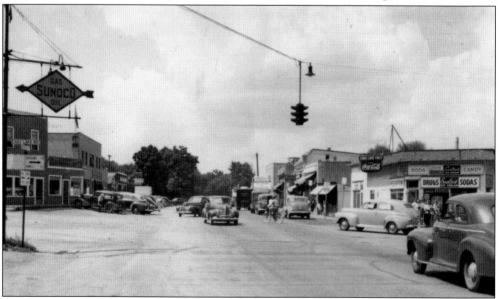

The Keego Harbor intersection of Orchard Lake and Cass Lake Roads is seen in this west-facing photograph from the 1940s. A drugstore stands on the northwest corner, a Sunoco station is on the southeast corner (only its sign is visible), and Keego Hardware is bustling down the street on the left. Vincent's Café is next to the hardware store, and Keego Theater is across the street. The well-established theater was the only such venue on this side of Pontiac. (Courtesy of Coral Lou Walling.)

Russ Rider and Dick Prutow were both employees of the Keego Hardware chain for years when the opportunity came along for them to buy a store. They partnered in 1953 to buy the Keego Harbor location, one of five stores with the Keego Hardware name. Here, Rider stands in the tool section in the 1950s. Porter Cable was a highly regarded professional line of power tools at the time. (Courtesy of Coral Lou Walling.)

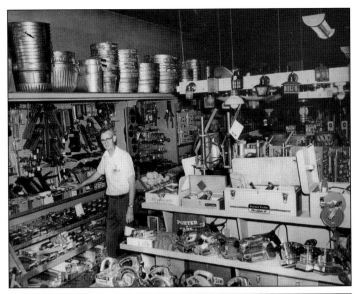

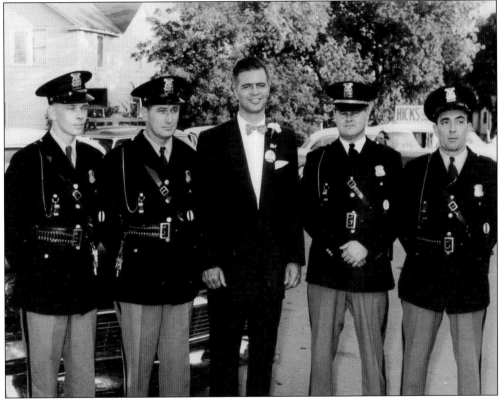

Gov. G. Mennen Williams (center) is seen here as he campaigns in Keego Harbor in 1956. He is posing with Keego Harbor police officers, from left to right, Dale Helgemo, Ken Fisk, Chief Calvin Baxter, and Jack Hirtubise. Baxter, the city's first police chief as well as a volunteer firefighter, died in the line of duty from injuries as a result of a fire at Spillwood Lanes on Pine Lake Avenue and Orchard Lake Roads just a few days after this photograph was taken. Baxter was the first on the scene. (Courtesy of GWBHS.)

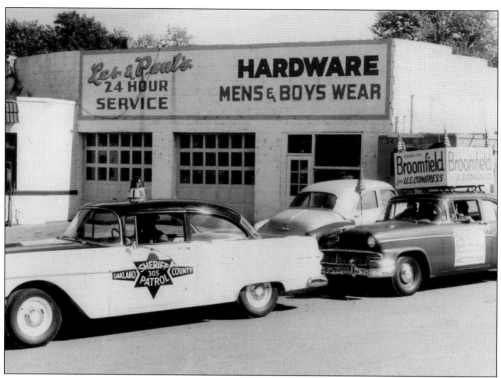

Les & Paul's Service at Cass Lake and Orchard Lake Roads is shown here in 1956. A car has a campaign sign for William Broomfield, who became the local congressman after getting elected soon after this photograph was taken. He served for over three decades. A boat dealer later occupied this corner. A strip mall with M&M Cleaners has been in this spot for many decades. (Courtesy of GWBHS.)

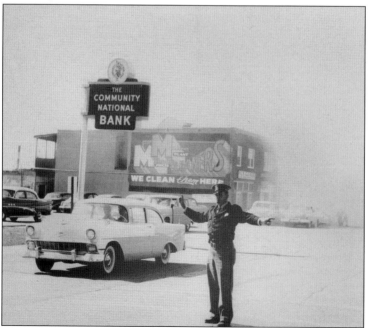

Community National Bank was one of several local banks in the 1950s and a mainstay in Keego Harbor before being swallowed up. The policeman is directing traffic for the funeral of police chief Calvin Baxter at Godhardt Funeral Home, across the street from the bank. M&M Cleaners, in the background, is still in business in virtually the same location. (Courtesy of GWBHS.)

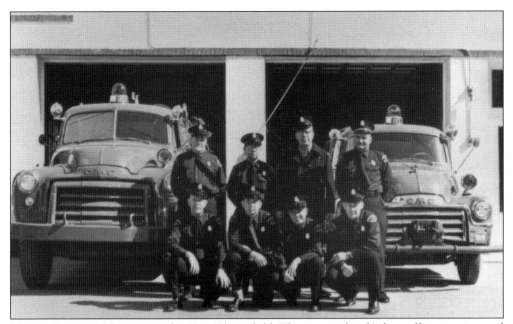

This is the second fire station for West Bloomfield. The state police had an office upstairs, and early on it took fire calls that would then be relayed to the station downstairs. The previous station, a wooden frame garage, was only a stone's throw from this later firehouse, which was light-years ahead of the early one. (Courtesy of Coral Lou Walling.)

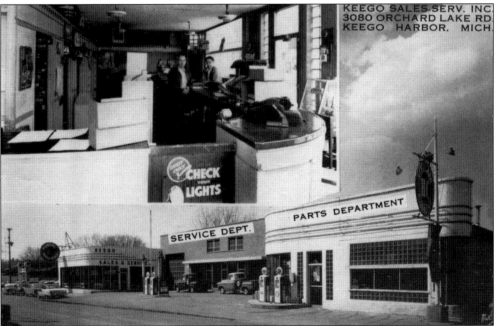

Keego Sales & Service in downtown Keego is seen here in the 1950s. The building still stands. Rumors abound that in the 1930s the owner of the station repaired cars owned by gangsters and, when necessary, dumped vehicles sought by police into Dollar Lake behind the garage because, so the stories go, the lake was bottomless. Local divers say the lake is neither bottomless or all that deep. (Courtesy of Joan Walsh.)

These boys are passing time on a summer day fishing off the little bridge on Willow Beach Avenue that crosses the canal that made Keego into Keego Harbor. Joseph Sawyer, the city's founder, dug the canal to connect Dollar Lake to Cass Lake, thereby creating a harbor of sorts. The canal, however, was too small and the bridge too low for any sizeable watercraft to pass through. (Courtesy of GWBHS.)

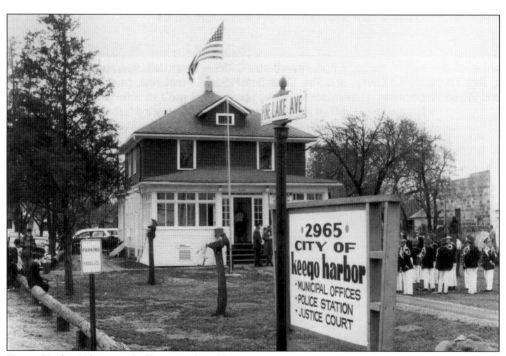

Keego Harbor's first city hall was in the old Keego Harbor School on Pridham Street at Orchard Lake Road. This photograph was taken in 1956 during Governor Williams's visit to the newly chartered city, which had achieved that status the previous year. This city hall, the city's second, was in a converted house at Pine Lake Avenue and Orchard Lake Road. (Courtesy of Coral Lou Walling.)

White City Bathing Beach, seen here in the 1950s, was located at the corner of Cass Lake Front and Cass Lake Road. After paying admission, visitors passed through the turnstile and had access to a sandy beach, playground equipment, food and drink, billiards, and more. The lake communities had lots of public spaces for those living nearby or visiting. Today, most of the lakefront has become private property or subdivision lots. A Vernors billboard is difficult to make out on the right. (Courtesy of Joan Walsh.)

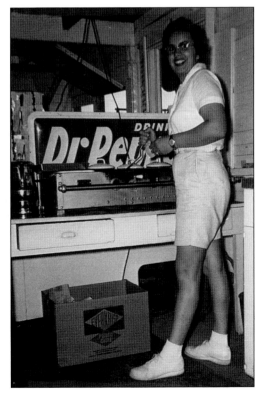

The beaches and resorts provided lots of employment for high school and college kids, as well as for anyone wanting a job with the benefits of working outdoors with a cool lake close by. Standard menu items were hot dogs, burgers, and ice cream. Pictured here is a White City kitchen worker in the 1950s. (Courtesy of Joan Walsh.)

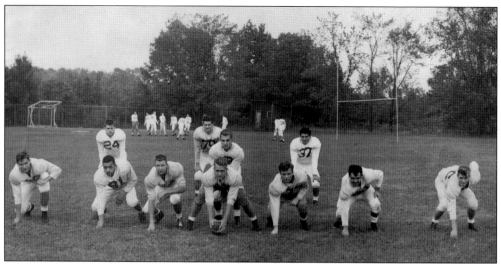

Frank Dickie (no. 77, left guard) and the Roosevelt School football team are warming up on game day. This field was in use for many decades for the local school teams. After the current high school was built with all of its own recreational fields, this old one became a soccer field for area intramural teams. In recent years, the field was sold, and homes were built. (Courtesy of Hugh Dickie.)

The Godhardt Funeral Home hearse was used as an ambulance at local car races. It is shown here in the 1950s. The injured is Bill Periard Jr. of Pine Lake Inn. He was a race car driver. Bill's grandfather was a mechanic on the early Indy racing circuit. Bill was also a scuba diver by profession. The funeral home became Godhardt-Tomlinson in 1972, when Ledge Tomlinson became a partner. (Courtesy of Mark Periard.)

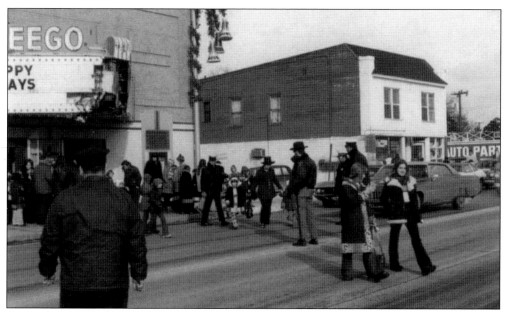

Orchard Lake Road through Keego Harbor was a two-lane thoroughfare until the early 1960s. The Keego Theater marquis had been a dominant symbol of the business district for decades. No one thought much about the widening of Orchard Lake Road to four lanes and the need to increase clearance beneath the theater's marquee until the day this photograph was snapped. (Courtesy of Coral Lou Walling.)

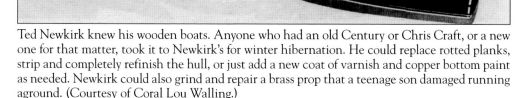
Ted Newkirk knew his wooden boats. Anyone who had an old Century or Chris Craft, or a new one for that matter, took it to Newkirk's for winter hibernation. He could replace rotted planks, strip and completely refinish the hull, or just add a new coat of varnish and copper bottom paint as needed. Newkirk could also grind and repair a brass prop that a teenage son damaged running aground. (Courtesy of Coral Lou Walling.)

This is the second building on this site at the east shore of Dollar Lake. Strong's Pavilion started as a dance hall and boat livery. It was later a skating rink and, lastly, a boat storage and restoration facility owned by Ted Newkirk and later Jim Olerich. When the building burned down in 1984, it was filled with classic and antique wooden boats. The loss was over $1 million. (Courtesy of Coral Lou Walling.)

The firefighters from West Bloomfield are about to hit the streets as members of the Goodfellows to sell newspapers on the corner, as they do every year, to raise money to buy Christmas presents for disadvantaged youths. The *Inter-Lake News* was a small local paper at the time. This photograph dates to the 1950s. Red Morgan is second from left. (Courtesy of Coral Lou Walling.)

West Bloomfield High football players Larry Hollister (right) and a friend are shown here in 1957 at the old football field on Summers Street. The West Bloomfield Lakers were rivals of the nearby Bloomfield Hills Barons. There was intense loyalty and emotion whenever these two teams met. Both schools boasted new buildings and names in 1957. Football was at its height in popularity, as the Detroit Lions were NFL champions at the time. (Courtesy of GWBHS.)

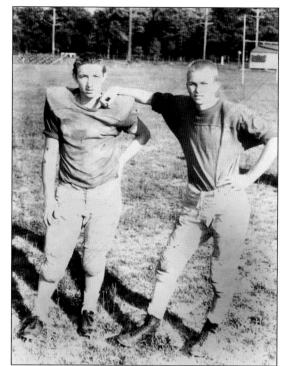

This is the dedication ceremony for the Keego Oakland County water supply system in 1966. A lot was happening in town in those years. A sewer system had been completed in 1960. The new municipal building and the maintenance garage were also dedicated. In 1968, the Tri-City Fire Department was created, breaking away from West Bloomfield. (Courtesy of GWBHS.)

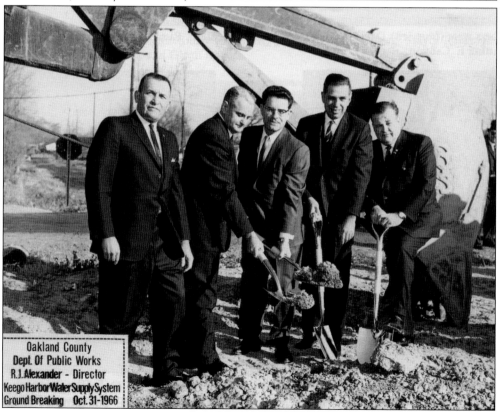

Oakland County
Dept. Of Public Works
R.J. Alexander - Director
Keego Harbor Water Supply System
Ground Breaking Oct. 31-1966

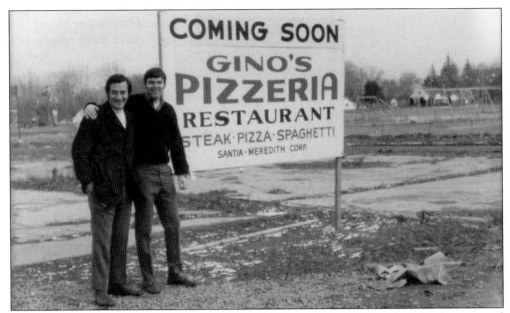

It might seem that Gino's Pizzeria is a latecomer to the town of Keego Harbor, but it has been around for over 40 years. The pizzeria's ground breaking is shown here in 1969. Santia Hall was added several years later. Other taverns with 40-plus years of history in Keego include Bachelor's One, Harbor House, Brewhaus, and Early Bird Café (formerly Frank's). (Courtesy of Coral Lou Walling.)

Places like the Backseat Saloon thrived in the 1970s and 1980s because 18-year-olds could legally drink. Live entertainment was everywhere, and this place had some of the best for years. Neil Woodward, seen here in the late 1970s, was one of the most popular musicians. Hank and Jack, Irish and Eversole, Charlie Springer, Shar, and Orange Lake Drive were among the many other acts that showed up to packed rooms. (Courtesy of Neil Woodward.)

It seems Keego Hardware had every type of screw known to man. Rows of wooden boxes formed shelves in the back corner for different-sized bolts. Nails were in big metal bins that customers could gather, weigh, and take to the counter. Rope and chain were available in many sizes by the foot. The faces behind the counter were always familiar and friendly. Shown here in the 1970s are Coral Lou Walling (rear), Judy Starick (front of counter), and George Tucker (left of counter). (Courtesy of Cora Lou Walling.)

Who has not been to the basement of the Keego Hardware Store? Whether it was to fix a broken window, replace a screen, get some pipe cut and threaded, or have a chain saw sharpened, Bob Starick was there day in and day out for decades. He could tell a customer how to fix a plumbing problem, order parts for underground sprinklers, and tell visitors how the fish were biting, summer or winter. (Courtesy of Coral Lou Walling.)

The Backseat Saloon, a Keego Harbor landmark, now gone, was one of the oldest structures left in the small city before it was torn down. An office building was erected in its place several years ago. Most people do not know that its early life was as an icehouse. Ice harvested from Dollar Lake, and potentially Cass Lake, was conveniently close to the small, two-story brick building on Orchard Lake Road, a main thoroughfare. The icehouse's location made it easy to load out and transport the product to customers. (Author's collection.)

The days are gone when customers can go to their corner hardware store and buy power tools, lawn mowers, BB guns, fishing tackle, bait, used ice skates, docks, paint, and plumbing and electrical supplies and put it all on a personal charge account—and where they knew everyone by first name. Keego Hardware served the community for over seven decades before closing. Shown here are Coral Lou and Jerry Walling with employee George Tucker near the nail bins. The Wallings became owners of the store in 1966. (Courtesy of Coral Lou Walling.)

About the Organization

By the early 1970s, Orchard Lake and the many square miles surrounding it had become a sprawling suburbia, still scattered with reminders of its recent past as a community of farms and orchards. The days of trolleys, hotels, and summer vacationers were a distant memory, and no one lived on Apple Island anymore. It had been many generations since tribes of American Indians had called this land their home. The development of the area inspired a small group of citizens "interested in preserving the scenic and historic values of the surrounding area." The Orchard Lake Scenic and Historical Society (OLSHS) was formed in 1974. In 1978, the name was changed to the Greater West Bloomfield Historical Society (GWBHS) to better reflect the organization's focus on and inclusion of Orchard Lake, Keego Harbor, and Sylvan Lake. The longevity of the organization is a testament to the hard work and dedication of countless volunteers who treasure the stories and natural beauty of Greater West Bloomfield, just as the OLSHS founders did in 1974.

In 1854, a structure was built as the Orchard Lake House at 3951 Orchard Lake Road. It was later renamed the Orchard Lake Hotel. It was razed and replaced in 1938, with the current structure housing the Orchard Lake City Hall. In 1987, when a new city hall was constructed, GWBHS was granted use of the building, now known as the Orchard Lake Museum. The museum exhibits objects from American Indians, fur traders, farmers, vacationers, and residents. Permanently displayed items include a 17th-century dugout canoe and the Keego Cinema neon sign, a landmark until 1998. Visit www.gwbhs.org to view virtual exhibits containing more than 4,000 photographs, maps, and documents.

Discover Thousands of Local History Books
Featuring Millions of Vintage Images

Arcadia Publishing, the leading local history publisher in the United States, is committed to making history accessible and meaningful through publishing books that celebrate and preserve the heritage of America's people and places.

Find more books like this at
www.arcadiapublishing.com

Search for your hometown history, your old stomping grounds, and even your favorite sports team.

Consistent with our mission to preserve history on a local level, this book was printed in South Carolina on American-made paper and manufactured entirely in the United States. Products carrying the accredited Forest Stewardship Council (FSC) label are printed on 100 percent FSC-certified paper.